FICTITIOUS
DISHES

FICTITIOUS DISHES

An Album *of* Literature's Most Memorable Meals

D I N A H F R I E D

HARPER DESIGN

An Imprint of Harper Collins Publishers

Fictitious Dishes
An Album of Literature's Most Memorable Meals

HarperCollins books may be purchased for educational, business, or sales promotional use. For information please e-mail the Special Markets Department at SPsales@harpercollins.com.

First published in 2014 by
Harper Design
An Imprint of HarperCollins *Publishers*
10 East 53rd Street, New York, NY 10022
Tel: (212) 207-7000
Fax: (212) 207-7654
www.harpercollinspublishers.com
harperdesign@harpercollins.com

Distributed throughout the world by
HarperCollins *Publishers*
10 East 53rd Street, New York, NY 10022

ISBN 978-0-06-227983-5
Library of Congress Control Number: 2013930677

Book design and photography by Dinah Fried
Photo retouching by Juan Zambrano

Typeset in Chronicle Text and Proxima Nova

Illustration Credits
Page 12: Top row, left: William Sharp, from *Heidi* by Johanna Spyri. New York: Grosset & Dunlap, Inc., 1945; Top row, center: George Cruikshank, from *Oliver Twist* by Charles Dickens. London: Bradbury & Evans, 1846. Middle row, left: Sir John Tenniel, from *Alice's Adventures in Wonderland* by Lewis Carroll. London: Macmillan and Co, 1865; Middle row, right: Beatrix Potter, from *The Tale of Peter Rabbit* by Beatrix Potter. London: Frederick Warne & Co., 1902. Bottom row, right: J.J. Grandville, from *Travels into Several Remote Nations of the World by Lemuel Gulliver, First a Surgeon and Then a Captain of Several Ships (Gulliver's Travels)* by Jonathan Swift. London: Hayward and Moore, 1840.

Printed in the U.S.A.
First Printing, 2014
14 15 16 LB 10 9 8 7 6 5 4 3 2

For Joe

I ate them like salad, books were my sandwich for lunch,
my tiffin and dinner and midnight munch. I tore out
the pages, ate them with salt, doused them with relish,
gnawed on the bindings, turned the chapters with my tongue!
Books by the dozen, the score and the billion. I carried
so many home I was hunchbacked for years. Philosophy,
art history, politics, social science, the poem, the essay, the
grandiose play, you name 'em, I ate 'em.

—RAY BRADBURY, *FAHRENHEIT 451*, 1953

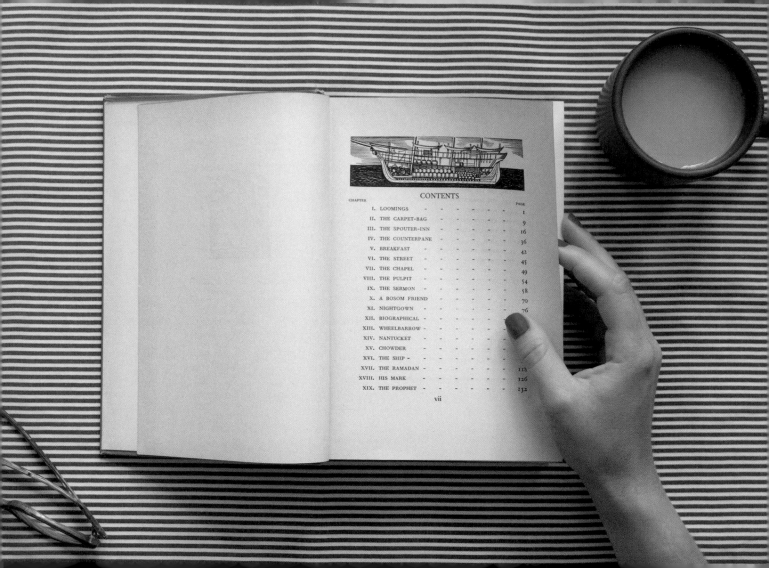

CONTENTS

CONTENTS

HEIDI

EMMA:

A NOVEL.

IN THREE VOLUMES.

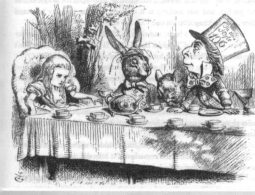

MOBY-DICK;

OR,

THE WHALE.

The Tale of
PETER RABBIT.

THE LIFE
&
Strange Surprizing
ADVENTURES
of
Robinson Crusoe

THE GREAT GATSBY

BY
F. SCOTT FITZGERALD

INTRODUCTION

Many of my most vivid memories from books are of the meals the characters eat. I read *Heidi* more than twenty years ago, but I can still taste the golden, cheesy toast that her grandfather serves her, and I can still feel the anticipation and comfort she experiences as she watches him prepare it over the open fire. I remember some meals for the moment they signify within a story: the minty cupcakes that Melissa gives to Chip in *The Corrections*—a marker of their love affair, which causes Chip's professional downfall and general unraveling. Other meals have stayed with me for the atmosphere they help convey. Recently, a friend told me that after reading *Lolita*, he began to drink gin and pineapple juice, a favorite combination of the novel's narrator, Humbert Humbert. I read *Lolita* when I was barely older than Lolita herself and was amazed that my friend's description of the cocktail catapulted me back to the distinct world that Nabokov had created: a sticky New England summer when an intoxicated, lust-lorn Humbert Humbert mows the unruly lawn in the hot sun, pining for Dolores, who is away at camp. Likewise, Melville's description of steaming chowder in *Moby-Dick* evokes a vision of Ishmael's seafaring life: salty, damp ocean air on a dark evening; finding solace in a cozy, warmly lit inn with a toasty dining room filled with good cheer and the rich smell of fresh seafood.

Reading and eating are natural companions, and they've got a lot in common. Reading is consumption. Eating is consumption. Both are comforting, nourishing, restorative, relaxing, and mostly enjoyable. They can energize you or put you to sleep. Heavy books and heavy meals both require a period of intense digestion. Just as reading great novels can transport you to another time and place, meals—good and bad ones alike—can conjure scenes very far away

from your kitchen table. Some of my favorite meals convey stories of origin and tradition; as a voracious reader, I devour my favorite books.

Which brings me to *Fictitious Dishes*. The book began a couple of years ago as a small design project while I was at the Rhode Island School of Design. I had the idea to cook, style, and photograph memorable meals I had read about in novels. I had a camera and a rickety tripod, a Whole Foods gift card, a cupboard full of mismatched dishes, and a fast-approaching deadline. After taking the first photos—*Oliver Twist*, *The Catcher in the Rye*, *Moby-Dick*, *Alice's Adventures in Wonderland*, and *The Girl with the Dragon Tattoo*—I was completely hooked on the whole process. There were so many more books to read, so many more meals to make. The project had to continue; I had to keep going, and I did, long past the assignment's due date. The result is the book you have in your hands.

Fictitious Dishes has challenged me to cook outside of my comfort zone. An almost-vegetarian, I never dreamed I'd find myself at my local butcher, asking for a pig kidney (for *Ulysses*) or pulling apart a week-old chicken carcass (for *The Amazing Adventures of Kavalier and Clay*). I cooked bananas eleven ways (for *Gravity's Rainbow*), including several failed attempts to mold them into the shape of a lion rampant; learned how to make Turkish delight from scratch (for *The Lion, the Witch and the Wardrobe*); and made my first apple pie ever (for *On the Road*). Though I'm generally quite squeamish about old food, I collected weeks' worth of rotting scraps (for *The Metamorphosis*).

The book has also allowed me to indulge in a daily activity I've always enjoyed—setting the table—and transform it into something else. Preparing for each photo shoot was a delightful and obsessive treasure hunt. The search for

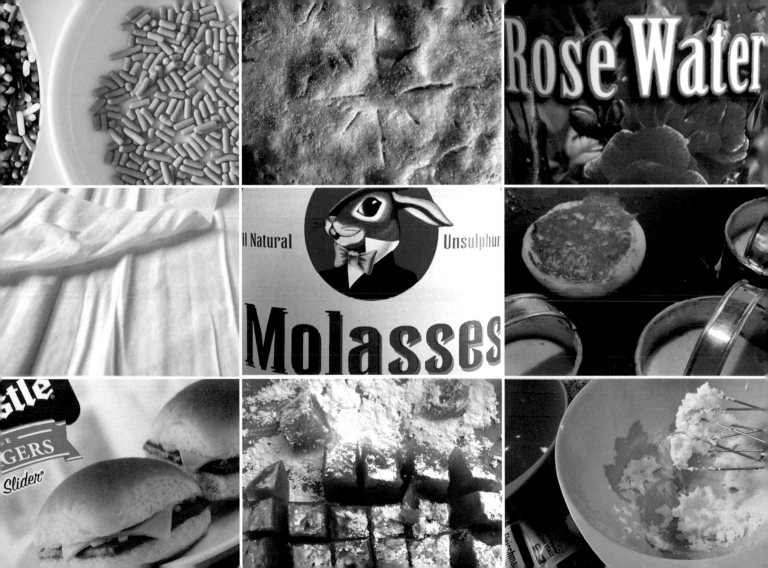

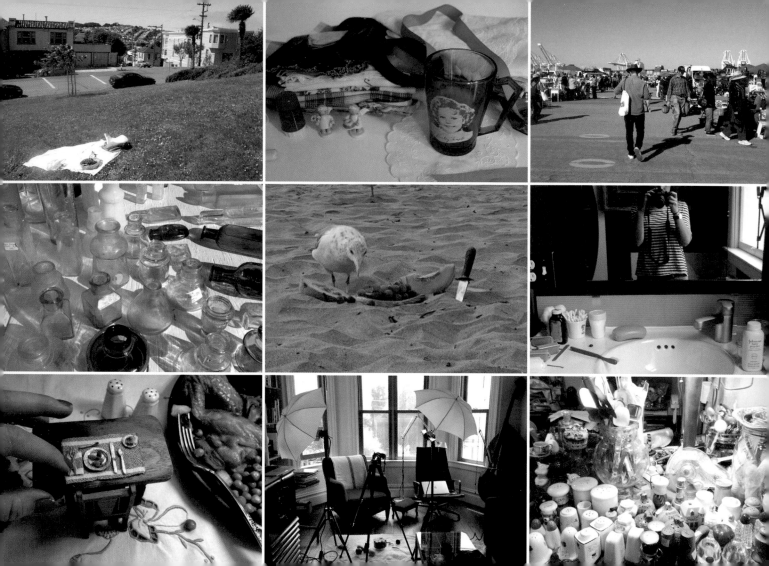

props took over my life—and my bank account. I pillaged the kitchen cupboards of friends and family members; I combed thrift stores, flea markets, eBay, Etsy, and some very sketchy yard sales. My eyes were constantly peeled for the perfect tablecloth or butter knife or saltshaker or plastic doodad. I wouldn't take my *Moby-Dick* picture until I could get my hands on the right pewter beer stein—a detail never mentioned in the book but that I felt had to be in the photo because it just seemed so right. I needed an old skeleton key for *The Secret Garden*, and my husband serendipitously found one on his grandfather's ancient key ring. Like magic.

I loved styling each photograph down to the smallest detail. I rarely set the meals on an actual table, though: I used wooden boards, boxes, pillowcases, a piece of Formica I found on the street, a seventy-five-year-old dish towel that belonged to my great-grandmother. I took most of the photos on my kitchen or living-room floor and lit them with a slapped-together combination of photo lights and random household lamps. "Big Two-Hearted River" was shot on a weekend trip to Big Sur. *Blueberries for Sal* was shot on a small patch of greenery on a sidewalk in San Francisco. I took the *Robinson Crusoe* photo on the beach surrounded by approximately five hundred hungry seagulls in Santa Cruz.

Whether I worked at home or on the road, making *Fictitious Dishes* has brought me deeper into the books I read. Each step of the process of making these tabletop scenes—digesting the author's words, imagining the setting and the food served, doing research, shopping, cooking, styling, and shooting—has been an extension of my own experience of the books included on the following pages. For readers who are familiar with these great works, I hope the photographs will spark a memory and transport you back into fictional worlds; to those of you who are unfamiliar with them, I offer a little taste of the stories.

THE DISHES

MOBY-DICK; OR THE WHALE

HERMAN MELVILLE, 1851

OH, SWEET FRIENDS! HEARKEN TO ME. It was made of small juicy clams, scarcely bigger than hazel nuts, mixed with pounded ship biscuit, and salted pork cut up into little flakes; the whole enriched with butter, and plentifully seasoned with pepper and salt. Our appetites being sharpened by the frosty voyage, and in particular, Queequeg seeing his favorite fishing food before him, and the chowder being surpassingly excellent, we despatched it with great expedition . . . while plying our spoons in the bowl, thinks I to myself, I wonder now if this here has any effect on the head? What's that stultifying saying about chowder-headed people?

- Melville's work is greatly influenced by the time he spent in the South Seas (1841–44), where he worked as a sailor on the whaler *Acushnet*, stayed with a native tribe on the Marquesas Islands, and lived as a beachcomber in Tahiti.
- Melville dedicated the book to his friend, author Nathaniel Hawthorne.
- The 1930 Lakeside Press edition featured Rockwell Kent's haunting black-and-white ink illustrations, now the most iconic visual representations of the novel.
- Ishmael and Queequeg eat creamy New England clam chowder, but there are several other chowders native to their respective regions. Manhattan clam chowder is a clear, tomato-based soup; New Jersey clam chowder is known for its Old Bay crab spice and asparagus; Rhode Island clam chowder has a clear, buttery broth; Hatteras clam chowder is seasoned with lots of white and black pepper; and Florida's Minorcan clam chowder is spicy, thanks to the datil pepper in it.

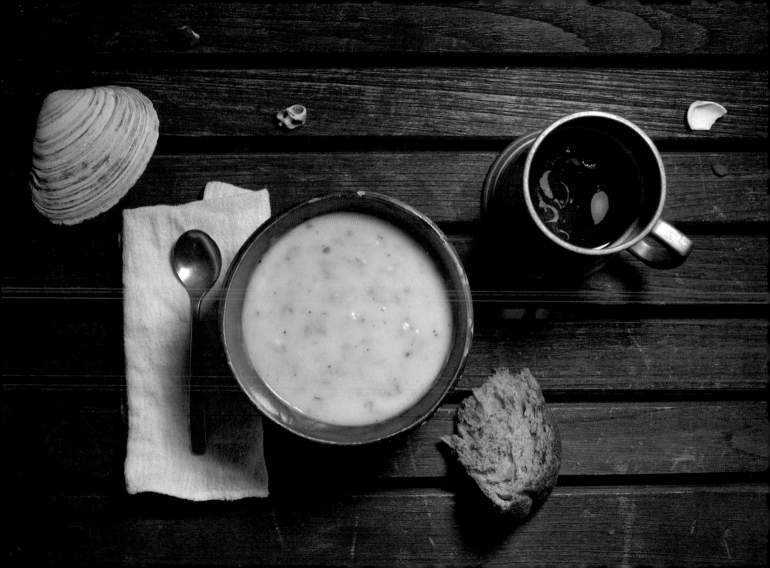

ON THE ROAD

JACK KEROUAC, 1957

BUT I HAD TO GET GOING AND STOP MOANING, so I picked up my bag, said so long to the old hotelkeeper sitting by his spittoon, and went to eat. I ate apple pie and ice cream—it was getting better as I got deeper into Iowa, the pie bigger, the ice cream richer.

- Kerouac typed the first draft of his manuscript on a 120-foot continuous scroll of tracing-paper sheets taped together, using much of what he had written in notebooks he carried with him while on the travels that inspired the novel.
- Although almost all of the characters in the novel were based on Kerouac's friends and acquaintances, his publisher objected to his using their real names, so Neal Cassady was fictionalized as Dean Moriarty; Allen Ginsberg as Carlo Marx; William S. Burroughs as Old Bull Lee; Joan Vollmer as Jane; and so on.
- Apple pie has long been a symbol of Americanism; on May 3, 1902, an article in the *New York Times* stated, "Pie is the American synonym for prosperity and its varying contents the calendar of the changing seasons. Pie is the food of the heroic. No pie-eating people can be permanently vanquished."
- According to a survey of the members of the International Ice Cream Association, vanilla is America's most popular ice cream: it's the favorite flavor of 29 percent of the population.

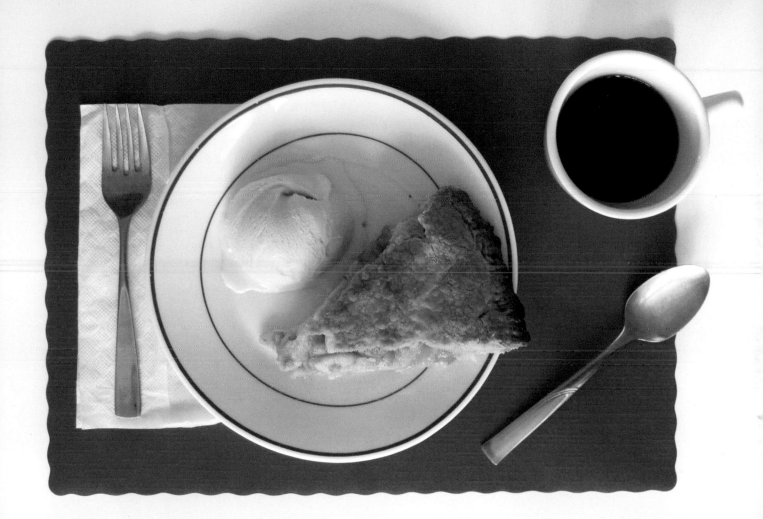

SWANN'S WAY

MARCEL PROUST, 1913

ONE DAY IN WINTER, as I came home, my mother, seeing that I was cold, suggested that, contrary to my habit, I have a little tea. I refused at first and then, I do not know why, changed my mind. She sent for one of those squat, plump cakes called petites madeleines that look as though they have been molded in the grooved valve of a scallop-shell. And soon, mechanically, oppressed by the gloomy day and the prospect of a sad future, I carried to my lips a spoonful of the tea in which I had let soften a piece of madeleine. But at the very instant when the mouthful of tea mixed with cake-crumbs touched my palate, I quivered, attentive to the extraordinary thing that was happening in me. A delicious pleasure had invaded me, isolated me, without my having any notion as to its cause. It had immediately made the vicissitudes of life unimportant to me, its disasters innocuous, its brevity illusory, acting in the same way that love acts, by filling me with a precious essence: or rather this essence was not in me, it was me.

- Madeleines weren't the only cookies around in 1913; Oreos, Mallomars, and fortune cookies were all introduced within a year of the publication of *Swann's Way*.
- The "episode of the madeleine" is the most famous scene in the lengthy novel, and remains a touchstone for the power of memory.
- It took Proust thirteen years to write *In Search of Lost Time* (1909–22). The seven volumes were published over fourteen years (1913–27) and feature more than two thousand characters.

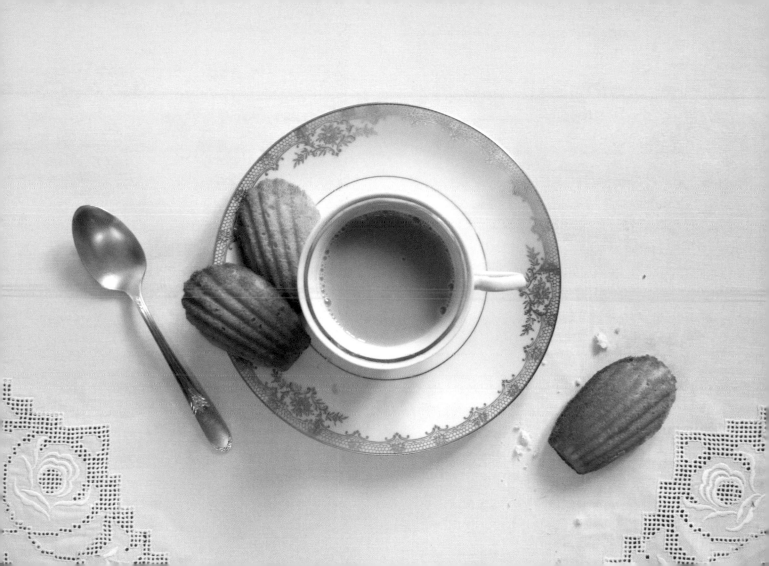

LITTLE WOMEN

LOUISA MAY ALCOTT, 1868–69

THE ARRAY OF POTS RATHER AMAZED HER AT FIRST, but John was so fond of jelly, and the nice little jars would look so well on the top shelf, that Meg resolved to fill them all, and spent a long day picking, boiling, straining, and fussing over her jelly. She did her best, she asked advice of Mrs. Cornelius, she racked her brain to remember what Hannah did that she left undone, she reboiled, resugared, and restrained, but that dreadful stuff wouldn't "jell."

She longed to run home, bib and all, and ask Mother to lend her a hand, but John and she had agreed that they would never annoy anyone with their private worries, experiments, or quarrels. . . . So Meg wrestled alone with the refractory sweetmeats all that hot summer day, and at five o'clock sat down in her topsy-turvey kitchen, wrung her bedaubed hands, lifted up her voice and wept.

- *Little Women* was a semiautobiographical account of Alcott's own childhood experience; the second of four daughters, she grew up in Massachusetts.
- Raised a transcendentalist, Alcott grew up in the company of her father's friends, including writers Ralph Waldo Emerson, Henry David Thoreau, and Nathaniel Hawthorne.
- Alcott was a strong advocate of abolition and women's rights.
- The word "jelly" comes from the Middle English word *geli*, which derived from the Latin *gelare*, meaning "to freeze."

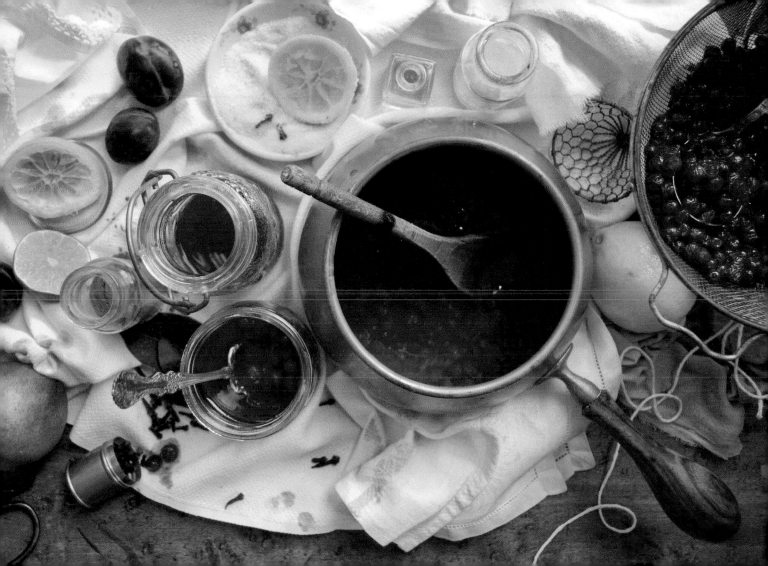

THE SECRET GARDEN

FRANCES HODGSON BURNETT, 1910–11

DICKON MADE THE STIMULATING DISCOVERY that in the wood in the park outside the garden where Mary had first found him piping to the wild creatures there was a deep little hollow where you could build a sort of tiny oven with stones and roast potatoes and eggs in it. Roasted eggs were a previously unknown luxury and very hot potatoes with salt and fresh butter in them were fit for a woodland king—besides being deliciously satisfying. You could buy both potatoes and eggs and eat as many as you liked without feeling as if you were taking food out of the mouths of fourteen people.

- The once wealthy Burnett began writing at the age of nineteen as a means of earning extra money, as her family—which included two brothers and two sisters—struggled financially after her father's premature death.
- Burnett's interest in Christian Science is reflected in *The Secret Garden*, particularly the healing "magic" that Mary believes heals both Colin and the garden.
- The potato was the first vegetable grown in space, aboard the Space Shuttle *Columbia* in 1995; NASA hired top scientists to develop extremely nutritious potatoes (called Quantum Tubers) to feed astronauts during long space voyages.
- A hen can lay as many as 335 eggs per year—that's one egg every twenty-six hours.

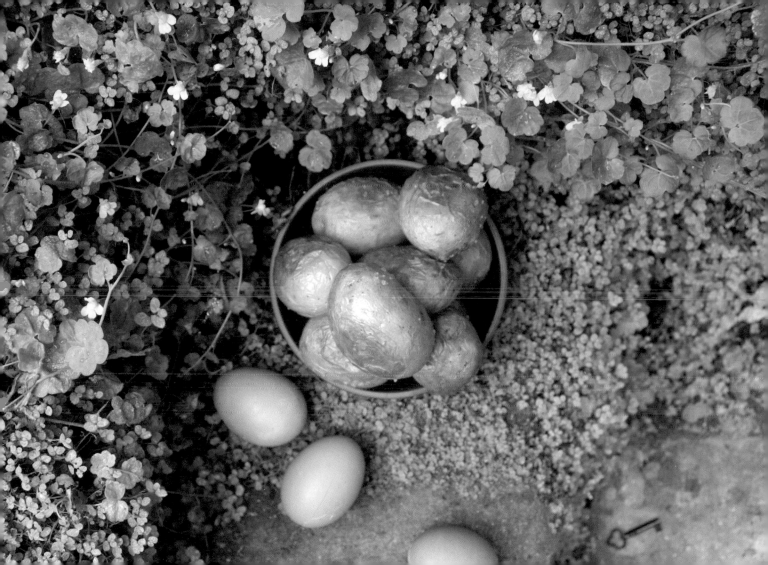

GULLIVER'S TRAVELS

JONATHAN SWIFT, 1726

THE QUEEN BECAME SO FOND OF MY COMPANY, that she could not dine without me. I had a table placed upon the same at which her majesty ate, just at her left elbow, and a chair to sit on.... I had an entire set of silver dishes and plates, and other necessaries, which, in proportion to those of the queen, were not much bigger than what I have seen in a London toy-shop for the furniture of a baby-house.... Her majesty used to put a bit of meat upon one of my dishes, out of which I carved for myself, and her diversion was to see me eat in miniature: for the queen (who had indeed but a weak stomach) took up, at one mouthful, as much as a dozen English farmers could eat at a meal, which to me was for some time a very nauseous sight. She would craunch the wing of a lark, bones and all, between her teeth, although it were nine times as large as that of a full-grown turkey; and put a bit of bread into her mouth as big as two twelve-penny loaves.

- In Part II of the novel, Gulliver spends time in Brobdingnag, where the average man is seventy-two feet tall. Here, besides the large box in which he was usually carried, the queen builds Gulliver a little house, "for the convenience of traveling."
- *Gulliver's Travels* was controversial when first published, due to the frank depiction of bodily functions, and was not published in its entirety until ten years later—offensive descriptions and all.
- Originating in Swift's novel, the adjective "Lilliputian" has entered the lexicons of many languages and is used in reference to those things that are "small," "trivial," even "petty."

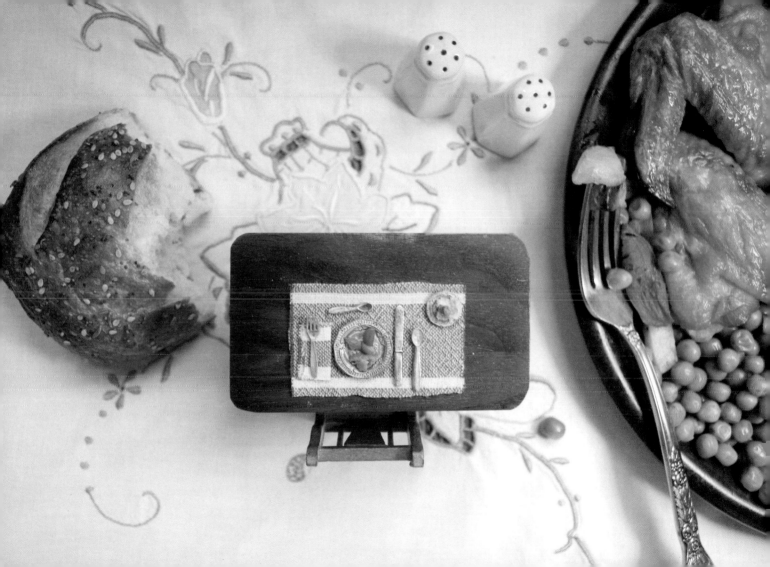

THE CORRECTIONS

JONATHAN FRANZEN, 2001

"WHY ARE YOU BRINGING ME CUPCAKES?" he said.

Melissa knelt and set the plate on his doormat among the pulverized remains of ivy and dead tulips. "I'll just leave them here,'" she said, "and you can do whatever you want with them. Goodbye!" She spread her arms and pirouetted off the doorstep and ran up the flagstone path on tiptoe.

The cupcakes were full of butter and frosted with a butter frosting. After he'd washed his hands and opened a bottle of Chardonnay he ate four of them and put the uncooked fish in the refrigerator. The skins of the overbaked squash were like inner-tube rubber. . . . He lowered the blinds and drank the wine and ate two more cupcakes, detecting peppermint in them, a faint buttery peppermint, before he slept.

- *The Corrections* won the National Book Award for Fiction in 2001 and the James Tait Black Memorial Prize in 2002.
- The first known mention of the cupcake was in 1796, in a recipe for "cake to be baked in small cups" from *American Cookery* by Amelia Simmons.
- The classic Hostess CupCake debuted in 1919 when two sold for five cents, but it wasn't until 1947 that its cream filling and signature squiggly line of white icing across the top were introduced.

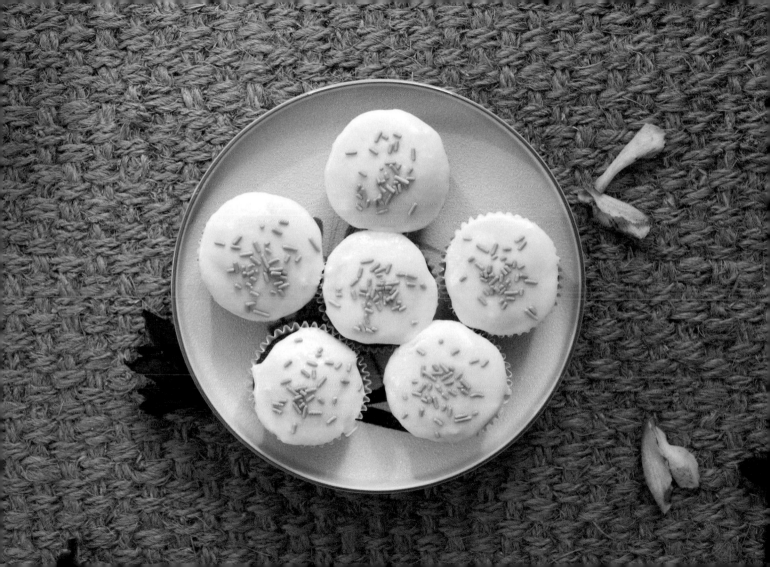

LOLITA

VLADIMIR NABOKOV, 1955

THE SUN MADE ITS USUAL ROUND OF THE HOUSE as the afternoon ripened into evening. I had a drink. And another. And yet another. Gin and pineapple juice, my favorite mixture, always double my energy. I decided to busy myself with our unkempt lawn. *Une petite attention.* It was crowded with dandelions, and a cursed dog—I loathe dogs—had defiled the flat stones where a sundial had once stood. Most of the dandelions had changed from suns to moons. The gin and Lolita were dancing in me, and I almost fell over the folding chairs that I attempted to dislodge. Incarnadine zebras!

- Thanks to the novel's cultural impact, "Lolita" has become a term in the popular vernacular, defined by *Webster's Dictionary* as "a precociously seductive girl."
- An avid lepidopterist, Nabokov wrote *Lolita* while on one of the butterfly-collecting trips he took every summer.
- Nabokov attempted to burn the manuscript halfway through writing it, but his wife, Véra, intervened.
- Due to its dark and disturbing sexual nature, *Lolita* was initially turned down by several American publishers, including Viking, Simon & Schuster, New Directions, Doubleday, and Farrar, Straus. It was eventually published in France in 1955, but it wasn't until its 1958 release in the United States that it received recognition as a great literary work.

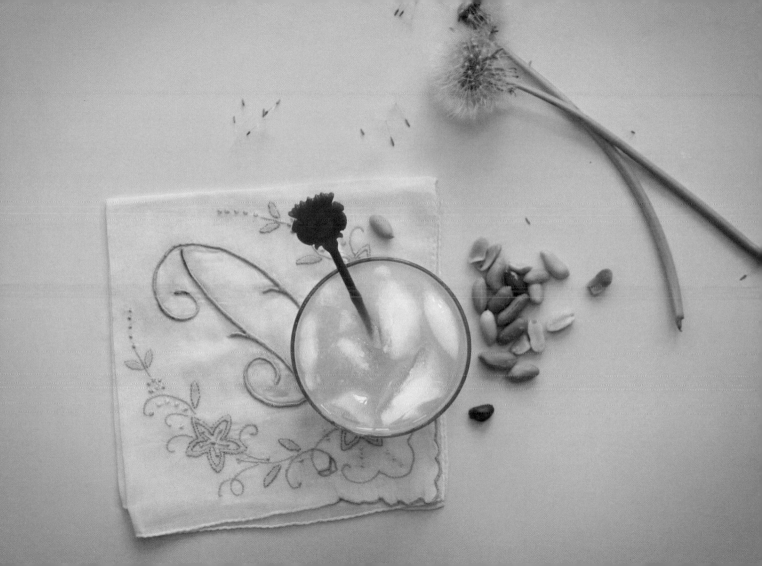

REBECCA

DAPHNE DU MAURIER, 1938

THOSE DRIPPING CRUMPETS, I can see them now. Tiny crisp wedges of toast, and piping-hot, flaky scones. Sandwiches of unknown nature, mysteriously flavored and quite delectable, and that very special gingerbread. Angel cake, that melted in the mouth, and his rather stodgier companion, bursting with peel and raisins. There was enough food there to keep a starving family for a week.

- Du Maurier drew inspiration for her gothic tales from her own family history and from the haunting legends of Cornwall, England, where she lived with her husband.
- Alfred Hitchcock adapted the novel into an Academy Award–winning film in 1940, starring Laurence Olivier and Joan Fontaine.
- An English favorite, crumpets are made of a simple batter of milk, flour, salt, and yeast and are traditionally cooked on a cast-iron griddle with a special metal "crumpet ring."
- The first known recipe for this cake using the name "angel cake" was published in Mrs. D. A. Lincoln's *The Original Boston Cooking School Cook Book* in 1884. It is also called angel food cake (a name first used in Fanny Farmer's 1896 edition of the *Boston Cooking School Cook Book*).

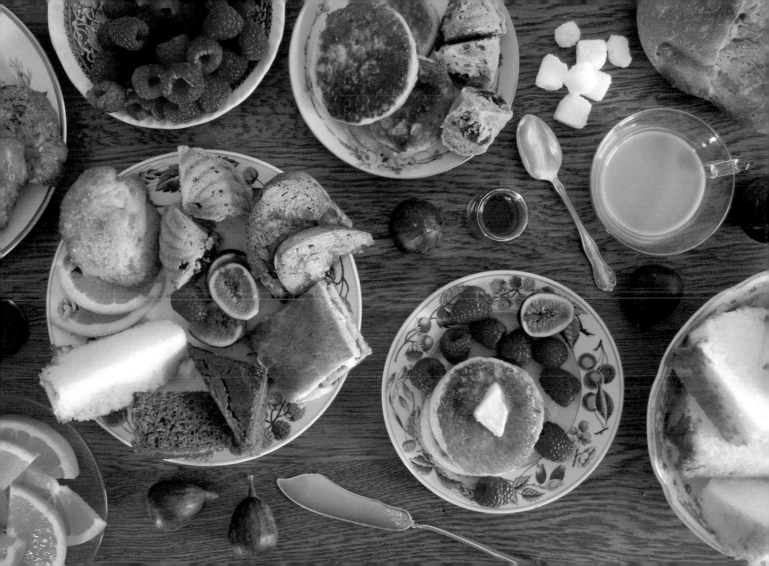

THE BLUEST EYE

TONI MORRISON, 1970

FRIEDA BROUGHT [PECOLA] FOUR GRAHAM CRACKERS on a saucer and some milk in a blue-and-white Shirley Temple cup. She was a long time with the milk, and gazed fondly at the silhouette of Shirley Temple's dimpled face. Frieda and she had a loving conversation about how cu-ute Shirley Temple was. I couldn't join them because I hated Shirley. Not because she was cute, but because she danced with Bojangles, who was my friend, my uncle, my daddy, and who ought to have been soft-shoeing it and chuckling with me. Instead he was enjoying, sharing, giving a lovely dance thing with one of those little white girls whose socks never slid down under their heels.

- In 1993, Toni Morrison became the first African American woman to win the Nobel Prize in Literature.
- Invented in 1829 by minister Sylvester Graham, graham crackers were originally considered a health food. They were part of the "Graham Diet"—a regimen meant to curb sexual appetite through the consumption of bland foods.
- Hazel Atlas Glass Company and US Glass Company produced millions of cobalt-blue glass mugs, bowls, and pitchers featuring the sweet face of child star Shirley Temple. In the 1930s and 1940s, these keepsakes were given away with the purchase of boxes of breakfast foods like Wheaties and Bisquick.
- The novel's protagonist, Pecola, is obsessed with Shirley Temple and loves to drink milk—both symbols of the whiteness she idealizes as a result of the intense racism that permeates her world.

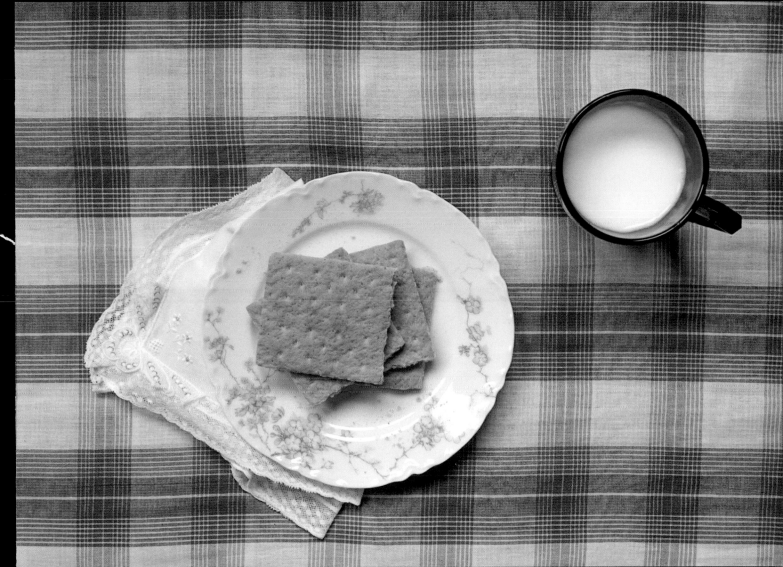

THE ADVENTURES OF HUCKLEBERRY FINN

MARK TWAIN, 1884

I HADN'T HAD A BITE TO EAT since yesterday, so Jim he got out some corn-dodgers and but-termilk, and pork and cabbage and greens—there ain't nothing in the world so good when it's cooked right—and whilst I eat my supper we talked and had a good time.

- Ernest Hemingway loved the novel and believed it was the seed of all American literature that followed it.
- Despite the book's extreme historical success, it has elicited a lot of controversy both in its negative depiction of the South and in its use of derogatory and racist language. It is, though, undeniably antislavery despite its use of certain terms that were socially acceptable at the time of its writing.
- Corn dodgers—similar to hush puppies (in the South) and johnnycakes (in the North)—are small cornmeal cakes that were a staple of early American cuisine.
- It is a Southern tradition to eat cabbage and collard greens on New Year's Day, as they are believed to ensure wealth in the coming year.

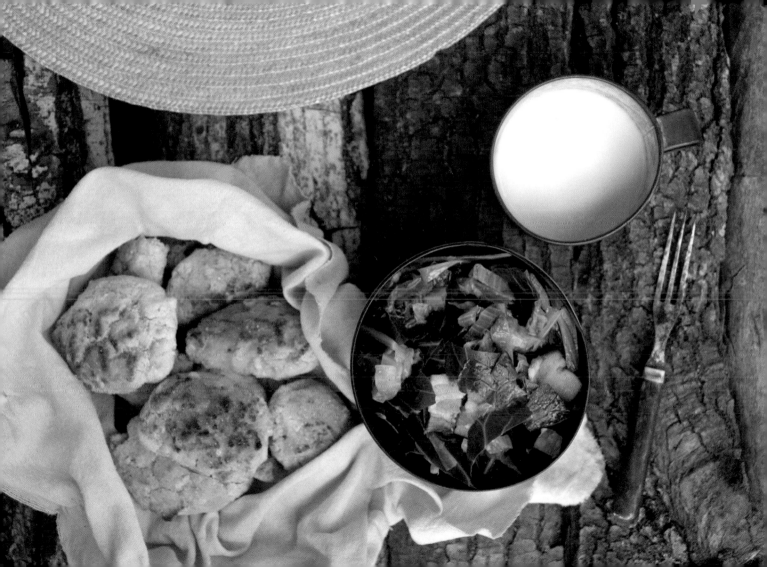

THE NAMESAKE

JHUMPA LAHIRI, 2003

ON A STICKY AUGUST EVENING two weeks before her due date, Ashima Ganguli stands in the kitchen of a Central Square apartment, combining Rice Krispies and Planters peanuts and chopped red onion in a bowl. She adds salt, lemon juice, thin slices of green chili pepper, wishing there were mustard oil to pour into the mix. Ashima has been consuming this concoction throughout her pregnancy, a humble approximation of the snack sold for pennies on Calcutta sidewalks and on railway platforms throughout India, spilling from newspaper cones. Even now that there is barely space inside her, it is the one thing she craves.

- In the novel's first scene, Ashima—pregnant and homesick—assembles a savory mixture similar to *bhelpuri*, an Indian snack made of puffed rice, chopped vegetables, and tamarind.
- Kellogg's Rice Krispies made their debut in 1928. The recipe for ever-popular Rice Krispie Treats first appeared on cereal boxes just over a decade later.
- The names for the cereal's elf mascots, Snap, Crackle, and Pop, come from a 1933 radio jingle, "Listen to the fairy song of health, the merry chorus sung by Kellogg's Rice Krispies as they merrily snap, crackle, and pop in a bowl of milk. If you've never heard food talking, now is your chance."
- Planters was founded in 1906 in Wilkes-Barre, Pennsylvania, by fruit vendor Amedeo Obici, who built a peanut roaster out of parts he found at a local scrapyard.
- *The Namesake*'s title refers to its protagonist, Nikhil, whose family's intended private pet name for him, Gogol (after Russian author Nikolai Gogol), becomes his official birth name by default.

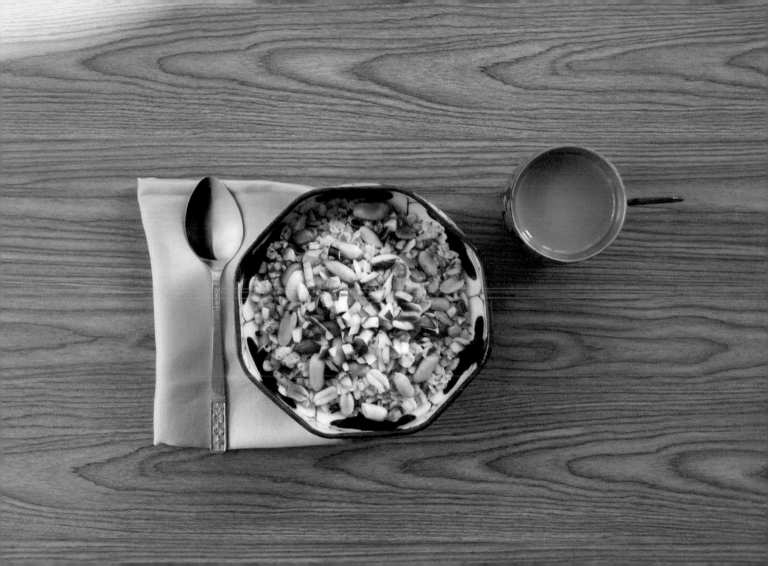

THE TALENTED MR. RIPLEY

PATRICIA HIGHSMITH, 1955

MARGE AND THE MAID CAME OUT of the kitchen carrying a steaming platter of spaghetti, a big bowl of salad, and a plate of bread. Dickie and Marge began to talk about the enlargement of some restaurant down on the beach. . . . There was nothing Tom could contribute.

He spent the time examining Dickie's rings. He liked them both: a large rectangular green stone set in gold on the third finger of his right hand, and on the little finger of the other hand a signet ring, larger and more ornate than the signet Mr. Greenleaf had worn. Dickie had long, bony hands, a little like his own hands, Tom thought.

"By the way, your father showed me around the Burke-Greenleaf yards before I left," Tom said. "He told me he'd made a lot of changes since you've seen it last. I was quite impressed."

"I suppose he offered you a job, too. Always on the lookout for promising young men." Dickie turned his fork round and round, and thrust a neat mass of spaghetti into his mouth.

"No, he didn't." Tom felt the luncheon couldn't have been going worse.

• It is at this meal that Tom first notices Dickie's rings, as well as the physical similarities between himself and his friend—two major factors that enable Tom to take on Dickie's identity.

• Highsmith's Ripley novels are often referred to collectively as the "Ripliad."

• It is estimated that Italians eat an average of sixty pounds of pasta yearly—a large bowl of pasta six days a week.

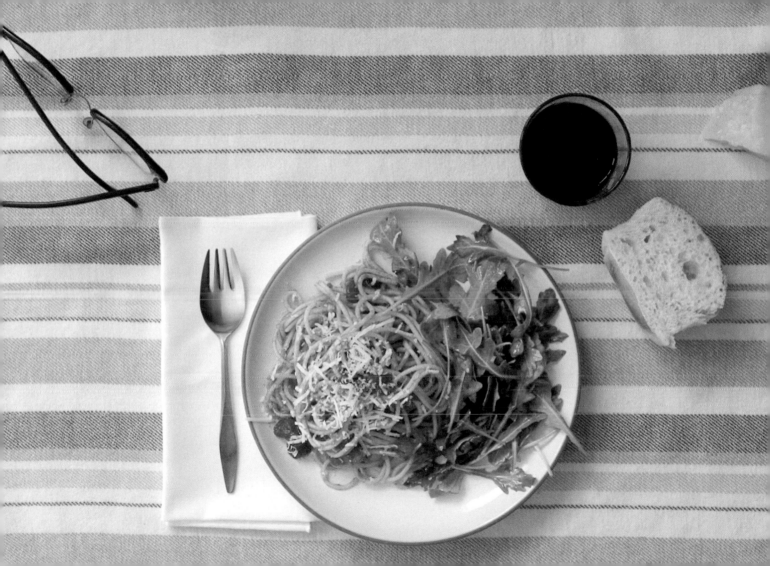

HOPSCOTCH

JULIO CORTÁZAR, 1963

"IF MY MATE RUNS OUT I'VE HAD IT," Oliveira thought. "My only real conversation is with this green gourd." He studied the strange behavior of the mate, how the herb would breathe fragrantly as it came up on top of the water and how it would dive as he sucked and would cling to itself, everything fine lost and all smell except for that little bit that would come up in the water like breath and stimulate his Argentinean iron lung, so sad and solitary. It had been some time now that Oliveira had been paying attention to unimportant things, and the little green gourd had the advantage that as he meditated upon it, it never occurred to his perfidious intelligence to endow it with such ideas as one extracts from mountains, the moon, the horizon, an adolescent girl, a bird, or a horse. "This mate might show me where the center is," Oliveira thought. . . . The problem consisted in grasping that unity without becoming a hero, without becoming a saint, or a criminal, or a boxing champ, or a statesman, or a shepherd. To grasp unity in the midst of diversity, so that that unity might be the vortex of a whirlwind and not the sediment in a clean, cold mate gourd.

- *Mate* is a popular South American infused beverage made by steeping dried leaves of the yerba maté plant in hot water, traditionally served in a hollowed calabash gourd with a metal straw, especially in Uruguay, Argentina, and southern Brazil.
- *Hopscotch* is written in a unique format, wherein the chapters can be read through consecutively or in a seemingly random order according to a table of instructions provided by the author. The book also has several alternate endings.

GONE WITH THE WIND

MARGARET MITCHELL, 1936

"SOME FOLKS THINKS AS HOW AH KIN FLY," grumbled Mammy, shuffling up the stairs. She entered puffing, with the expression of one who expects battle and welcomes it. In her large black hands was a tray upon which food smoked, two large yams covered with butter, a pile of buckwheat cakes dripping syrup, and a large slice of ham swimming in gravy. Catching sight of Mammy's burden, Scarlett's expression changed from one of minor irritation to obstinate belligerency. In the excitement of trying on dresses she had forgotten Mammy's ironclad rule that, before going to any party, the O'Hara girls must be crammed so full of food at home they would be unable to eat any refreshments at the party.

- *Gone with the Wind* won the National Book Award in 1936 and the Pulitzer Prize for Fiction in 1937.
- The novel has been adapted for both screen and stage many times—ranging from the Academy Award–winning 1939 film starring Vivien Leigh and Clark Gable to a much lesser-known nine-hour play produced in Japan in 1966.
- Buckwheat, cultivated in Southeast Asia as early as 6000 B.C., is not actually in the wheat family, as it is not a grass. It is related to the herbaceous plant sorrel and to rhubarb.
- In the United States, orange sweet potatoes are often mistakenly referred to as "yams," despite the fact that the two are unrelated root vegetables. Sweet potatoes originated in Central and South America; yams are native to Africa and Asia and are usually hard to find in the United States.

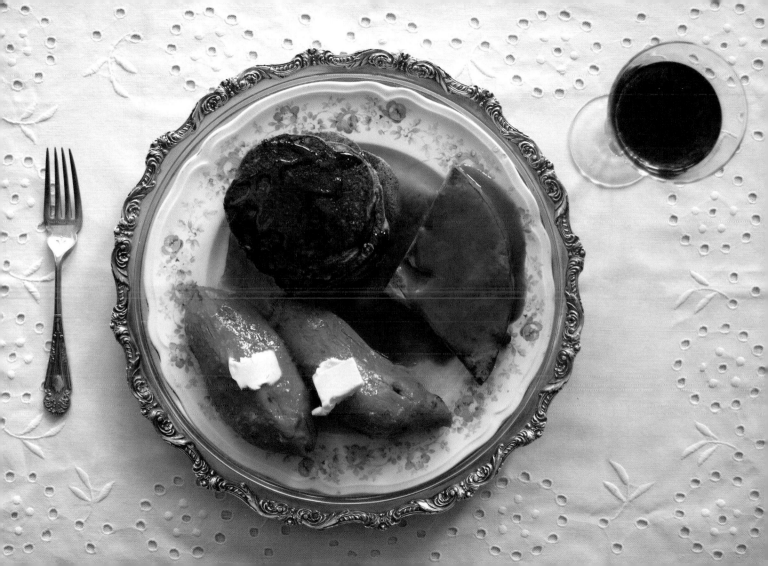

THE CATCHER IN THE RYE

J. D. SALINGER, 1951

I'M A VERY LIGHT EATER. I really am. That's why I'm so damn skinny. I was supposed to be on this diet where you eat a lot of starches and crap, to gain weight and all, but I didn't ever do it. When I'm out somewhere, I generally just eat a Swiss cheese sandwich and a malted milk. It isn't much, but you get quite a lot of vitamins in the malted milk. H. V. Caulfield. Holden Vitamin Caulfield.

- Salinger's father was a ham and cheese importer.
- *The Catcher in the Rye* was published in 1951, a year before the first diet soda, No-Cal, was marketed. Holden would probably have considered this beverage "crumby."
- Malted milk is a powder made from evaporated malted barley, wheat flour, and whole milk. It is used in bread and bagel dough to help it rise, biscuits, pancakes, candy like malt balls and Whoppers, and milkshakes.
- Salinger had very rigid and peculiar eating habits, which, according to his former girlfriend Joyce Maynard, included a breakfast of frozen peas and a dinner of ground lamb patties served very rare.

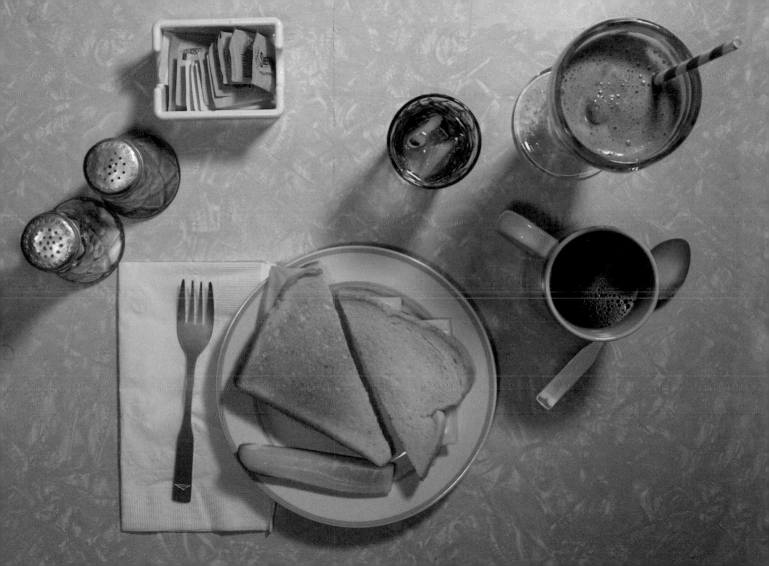

BEEZUS AND RAMONA

BEVERLY CLEARY, 1955

AFTER FATHER HAD SERVED THE CHICKEN and mashed potatoes and peas and Mother had passed the hot rolls, Beezus decided the time had come to tell Aunt Beatrice about being Sacajawea. . . .

"Last week—" said Beezus, looking at her aunt, who smiled as if she understood.

"Excuse me, Beezus," Mother cut in. "Ramona, we do not put jelly on our mashed potatoes."

"I like jelly on my mashed potatoes." Ramona stirred potato and jelly around with her fork.

"Ramona, you heard what your mother said." Father looked stern.

"If I can put butter on my mashed potatoes, why can't I put jelly? I put butter and jelly on toast," said Ramona.

Father couldn't help laughing. "That's a hard question to answer."

- Cleary's series of eight children's novels written between 1955 and 1999 follows Ramona Quimby from ages four through ten.
- One of the first written records of mashed potatoes is in Hannah Glasse's 1747 cookbook, *The Art of Cookery*.
- Though food chemist Edward Asselbergs didn't invent "instant mashed potato flakes" until 1962, freeze-dried potatoes— such as Incan *chuño*—date as far back as the thirteenth century.

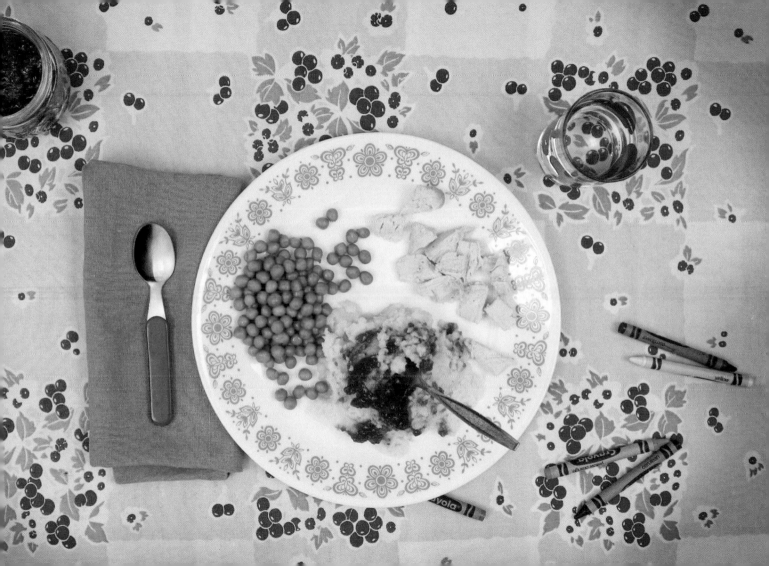

ROBINSON CRUSOE

DANIEL DEFOE, 1719

THE NEXT DAY, the sixteenth, I went up the same way again; and after going something further than I had gone the day before, I found the brook and the savannahs cease, and the country become more woody than before. In this part I found different fruits, and particularly I found melons upon the ground, in great abundance, and grapes upon the trees. The vines had spread, indeed, over the trees, and the clusters of grapes were just now in their prime, very ripe and rich. This was a surprising discovery, and I was exceeding glad of them; but I was warned by my experience to eat sparingly of them; remembering that when I was ashore in Barbary, the eating of grapes killed several of our Englishmen, who were slaves there, by throwing them into fluxes and fevers. But I found an excellent use for these grapes; and that was, to cure or dry them in the sun, and keep them as dried grapes or raisins are kept, which I thought would be, as indeed they were, wholesome and agreeable to eat when no grapes could be had.

- *Robinson Crusoe* is widely accepted as the first realistic novel, due to its use of verisimilitude, specificity of character and place, and focus on the emotional interiority and personal growth of its protagonist.
- There have been so many iterations and imitations of the Crusoe story of shipwreck survival and island living that a word exists to describe such a tale: a "Robinsonade."
- Crusoe's mythic tale has been retold and reinterpreted in countless ways—in books such as *The Swiss Family Robinson* and *The Lord of the Flies*; in films such as *Man Friday* and *Cast Away*; and in television shows including *Gilligan's Island* and *Lost*.
- First cultivated in Africa, melons are shown in Egyptian hieroglyphics dating from as far back as 2400 B.C.

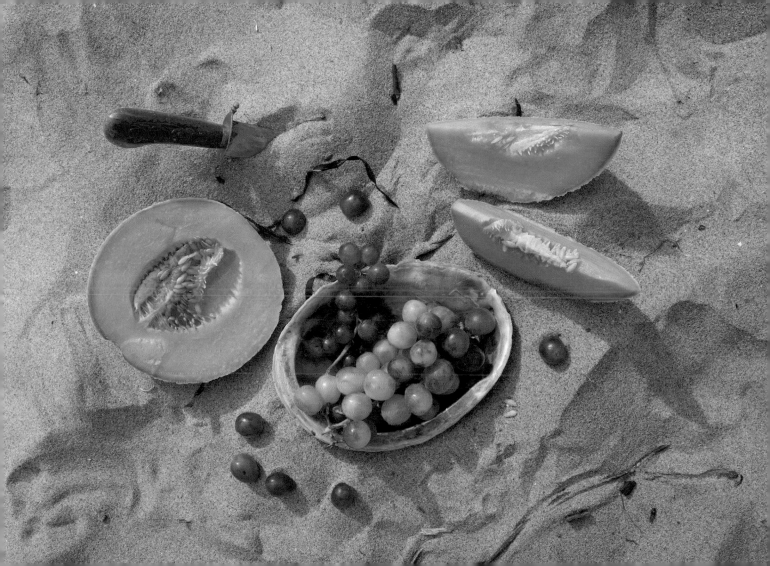

A WRINKLE IN TIME

MADELEINE L'ENGLE, 1962

"YOU'D BETTER CHECK THE MILK," Charles Wallace said to Meg now, his diction clearer and cleaner than that of most five-year-olds. "You know you don't like it when it gets skin on top."

"You put in more than twice enough milk." Meg peered into the saucepan.

Charles Wallace nodded serenely. "I thought Mother might like some."

"I might like what?" a voice said, and there was their mother standing in the doorway.

"Cocoa," Charles Wallace said. "Would you like a liverwurst-and-cream-cheese sandwich? I'll be happy to make you one."

"That would be lovely," Mrs. Murry said, "but I can make it myself if you're busy."

"No trouble at all." Charles Wallace slid down from his chair and trotted over to the refrigerator, his pajamaed feet padding softly as a kitten's. "How about you, Meg?" he asked. "Sandwich?"

- L'Engle's manuscript was rejected by twenty-six publishers before being bought in 1962 by Farrar, Straus and Giroux.
- The book won the Newbery Medal in 1963 and has been translated into more than fifteen languages.
- Liverwurst—"liver sausage"—is eaten commonly across Europe, and is served differently depending on the region. In Germany's Rhineland, it's fried and eaten with onion, apples, and potatoes; in Poland, it is often made of calf's liver and eaten on rye bread with spicy horseradish mustard; in Hungary, it is rolled into pancakes with cheese, and beef liverwurst on sliced bread with *murături* ("pickles") is a traditional Christmas Eve dinner.
- In 1872, when dairyman William Lawrence was trying to make Neufchâtel, he accidently developed a method for producing what he called "cream cheese," which in 1880 began to be marketed as Philadelphia brand cream cheese.

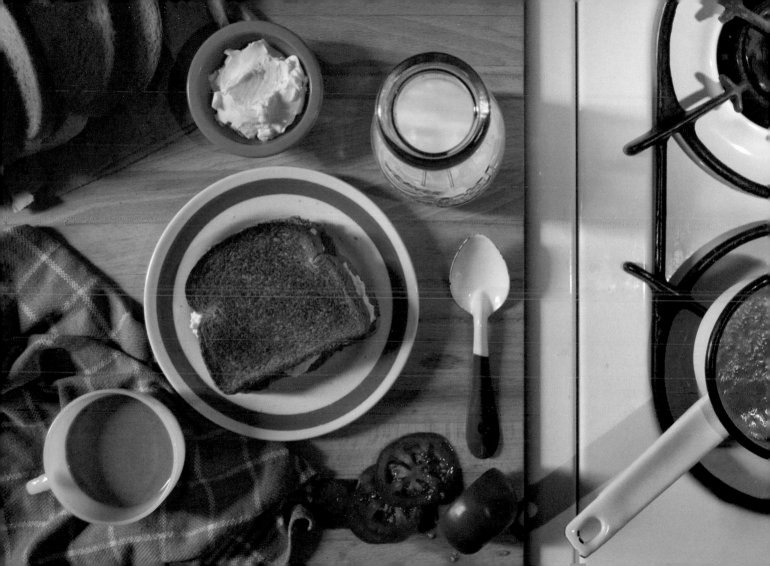

ONE HUNDRED YEARS OF SOLITUDE

GABRIEL GARCÍA MÁRQUEZ, 1967

ON RAINY AFTERNOONS, embroidering with a group of friends on the begonia porch, she would lose the thread of the conversation and a tear of nostalgia would salt her palate when she saw the strips of damp earth and the piles of mud that the earthworms had pushed up in the garden. Those secret tastes, defeated in the past by oranges and rhubarb, broke out into an irrepressible urge when she began to weep. She went back to eating earth. The first time she did it almost out of curiosity, sure that the bad taste would be the best cure for the temptation. And, in fact, she could not bear the earth in her mouth. But she persevered, overcome by the growing anxiety, and little by little she was getting back her ancestral appetite, the taste of primary minerals, the unbridled satisfaction of what was the original food.

- The passage quoted here describes the strange behavior of Rebeca—an orphan adopted by the Buendía family—who has a curious habit of eating dirt and whitewash.
- With the publication of *One Hundred Years of Solitude*, García Márquez earned international acclaim. He was awarded the Nobel Prize for Literature in 1982.
- The first written record of geophagy—the practice of eating soil—comes from Hippocrates and dates back two thousand years. Cornell University research has revealed that eating dirt can protect the stomach against certain toxins, parasites, and pathogens.

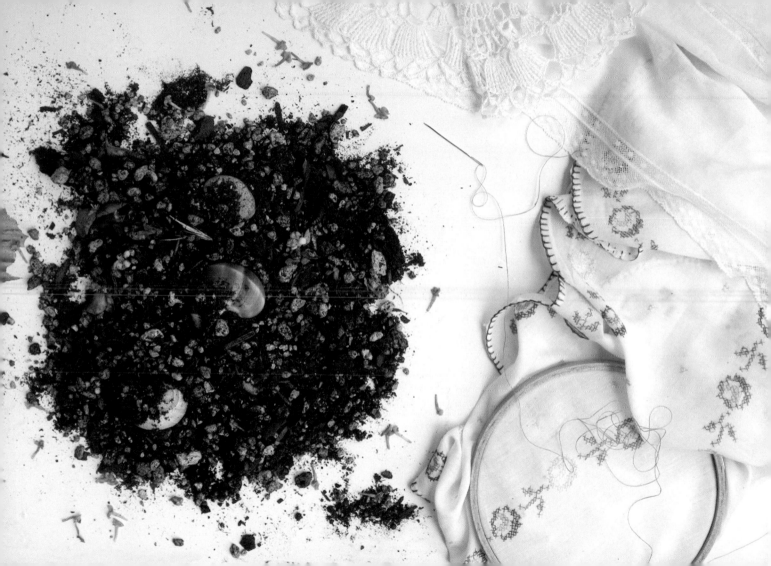

THE ROAD

CORMAC McCARTHY, 2006

HE UNROLLED THE MATTRESS PADS on the bunks for them to sit on and he opened the carton of pears and took out a can and set it on the table and clamped the lid with the can opener and began to turn the wheel. He looked at the boy. The boy was sitting quietly on the bunk, still wrapped in the blanket, watching. The man thought he had probably not fully committed himself to any of this. You could wake in the dark wet woods at any time. These will be the best pears you ever tasted, he said. The best. Just you wait.

They sat side by side and ate the can of pears. Then they ate a can of peaches. They licked the spoons and tipped the bowls and drank the rich sweet syrup.

- *The Road* was awarded the James Tait Black Memorial Prize for fiction in 2006 and the Pulitzer Prize for Fiction in 2007.
- While in an abandoned town, the man and the boy discover a bunker full of untouched food, clothes, tools, toiletries, and other useful items. The ordinary canned and preserved food they eat—which saves them from starvation—is, for them, a luxurious feast.
- Canned foods date back to the Napoleonic Wars (1803–15), when the French government offered a reward of 12,000 francs to anyone who could devise an inexpensive way of preserving food. A confectioner named Nicolas Appert—"the father of canning"—was the first to suggest storing food in airtight containers.

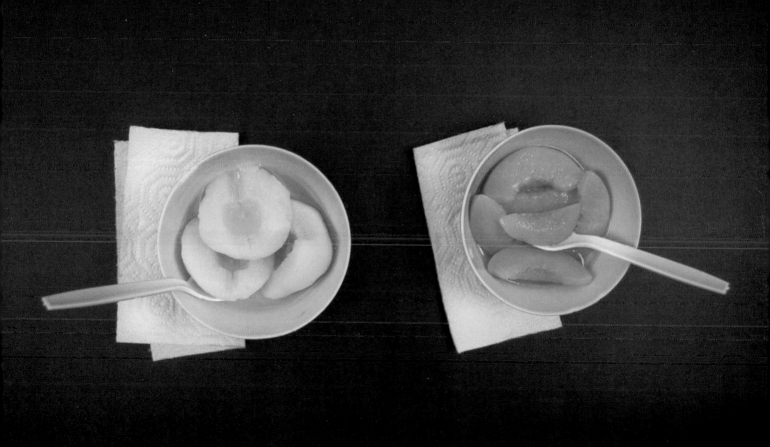

MADAME BOVARY

GUSTAVE FLAUBERT, 1856

A CONFECTIONER OF YVETOT had been entrusted with the tarts and sweets. As he had only just set up on the place, he had taken a lot of trouble, and at dessert he himself brought in a set dish that evoked loud cries of wonderment. To begin with, at its base there was a square of blue cardboard, representing a temple with porticoes, colonnades, and stucco statuettes all round, and in the niches constellations of gilt paper stars; then on the second stage was a dungeon of Savoy cake, surrounded by many fortifications in candied angelica, almonds, raisins, and quarters of oranges; and finally, on the upper platform a green field with rocks set in lakes of jam, nutshell boats, and a small Cupid balancing himself in a chocolate swing whose two uprights ended in real roses for balls at the top.

- Emma Bovary, disgusted by her husband's slow eating habits, is often forced to sit at the table long after she finishes and nibble restlessly on hazelnuts or draw with the point of her knife on the oilcloth.
- The scenes of extramarital romance were very shocking for the time. Flaubert and *La Revue de Paris*, the magazine that published the novel in serial form in the fall of 1856, were accused of obscenity by public prosecutors and were put on trial in 1857. After Flaubert's acquittal, the book became a bestseller.
- Dating back to the age of Louis XIV or earlier, Savoy cake is an old-fashioned light, spongy cake often baked or cut in a fancy and unusual shape.

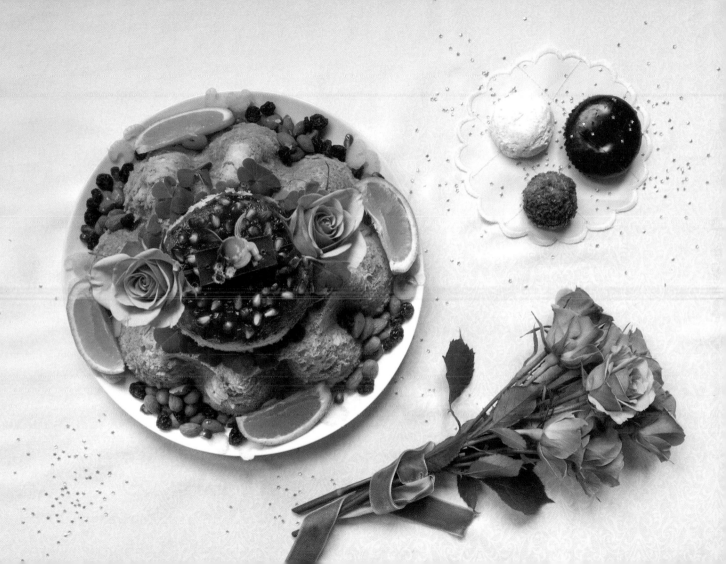

BLUEBERRIES FOR SAL

ROBERT McCLOSKEY, 1948

LITTLE SAL PICKED THREE BERRIES and dropped them in her little tin pail . . . *kuplink, kuplank, kuplunk*!

She picked three more berries and ate them. Then she picked more berries and dropped one in the pail—*kuplunk*! And the rest she ate. Then Little Sal ate all four blueberries out of her pail.

• *Blueberries for Sal* was awarded the Caldecott Honor Medal in 1949.
• McCloskey based his illustrations of Little Sal and her mother on his wife, Peggy, and his daughter, Sally.
• Wild blueberries are the official state fruit of Maine. The state harvested nearly 100 million pounds of them in 2012, almost reaching the record of 110 million pounds harvested in 2000.
• Blueberries have always grown abundantly in North America; Native Americans once called them "star berries"—thanks to the five-pointed shape of its blossom—and believed that the "Great Spirit" created the berries to feed hungry children during times of famine.

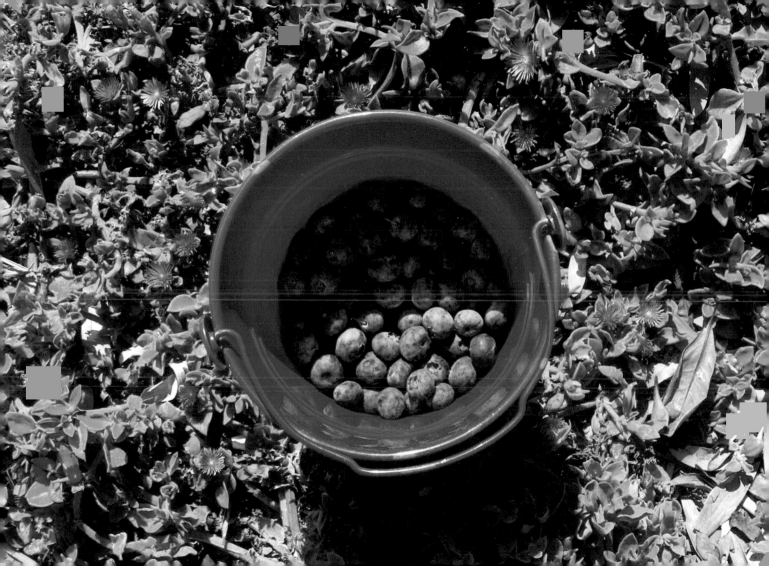

TO KILL A MOCKINGBIRD

HARPER LEE, 1960

"WE'RE NOT THROUGH YET. There'll be an appeal, you can count on that. Gracious alive, Cal, what's all this?" [Atticus] was staring at his breakfast plate.

Calpurnia said, "Tom Robinson's daddy sent you along this chicken this morning. I fixed it."

"You tell him I'm proud to get it—bet they don't have chicken for breakfast at the White House. What are these?"

"Rolls," said Calpurnia. "Estelle down at the hotel sent 'em."

Atticus looked up at her, puzzled, and she said, "You better step out here and see what's in the kitchen, Mr. Finch."

We followed him. The kitchen table was loaded with enough food to bury the family: hunks of salt pork, tomatoes, beans, even scuppernongs. Atticus grinned when he found a jar of pickled pigs' knuckles. "Reckon Aunty'll let me eat these in the diningroom?"

- In spite of the jury's unjustly finding Tom Robinson guilty, Tom's father gives Atticus a chicken the next day to thank him for defending him in court.
- Food is prevalent in the novel, with many mentions of tempting Southern treats, including ambrosia, turnip greens, Lane cake, crackling bread, peach pickles, dewberry tarts, fried pork chops, and Nehi cola.
- *To Kill a Mockingbird* won the Pulitzer Prize for Fiction in 1961. Despite her success, Lee never wrote another novel.
- The character of Dill is based on Lee's close childhood friend Truman Capote.

"CHICKEN SOUP WITH RICE"

MAURICE SENDAK, 1962

IN JUNE

I saw a charming group
of roses all begin
to droop
I pepped them up
with chicken soup!
Sprinkle once,
sprinkle twice
Sprinkle chicken soup
with rice

IN JULY

I'll take a peep
Into the cool and
fishy deep
Where chicken soup
is selling cheap
Selling once,
selling twice
Selling chicken soup
with rice

IN AUGUST

It will be so hot
I will become a
cooking pot
Cooking soup of course—
why not?
Cooking once,
cooking twice
Cooking chicken soup
with rice

- Chicken soup has long been a folk remedy for the common cold, but science has confirmed what mothers have always known: a bowl of hot chicken soup has anti-inflammatory properties.
- Chicken soup is an international favorite—in China it usually includes ginger, scallions, black pepper, sesame oil, and soy sauce; Greek *avgolemono* is made with beaten eggs and lemon; in Colombia, *ajiaco* is prepared with potatoes, sweet corn, avocado, capers, and *guascas*, an herb; and in Germany, *spätzle* is often added to chicken broth.
- Frank Sinatra loved chicken soup and always included among his food requests that a can of Campbell's Chicken Soup with Rice be provided in his dressing room.

FEAR AND LOATHING IN LAS VEGAS

HUNTER S. THOMPSON, 1971

"YOU GODDAMN HONKIES ARE ALL THE SAME." By this time he'd opened a new bottle of tequila and was quaffing it down. Then he grabbed a grapefruit and sliced it in half with a Gerber Mini-Magnum—a stainless-steel hunting knife with a blade like a fresh-honed straight razor.

"Where'd you get that knife?" I asked.

"Room service sent it up," he said. "I wanted something to cut the limes."

"What limes?"

"They didn't have any," he said. "They don't grow out here in the desert." He sliced the grapefruit into quarters . . . then into eighths . . . then sixteenths . . . then he began slashing aimlessly at the residue.

- *Fear and Loathing in Las Vegas* was first printed in two parts in *Rolling Stone* magazine. Enthusiastically received, the story introduced the then-unorthodox practice of "gonzo journalism"—a style that could be highly subjective and often included the writer as part of the article.
- The book is so effectively surrealistic that when Thompson reread it, he claimed that he had no idea what was real and what he had invented.
- Hunter S. Thompson took breakfast very seriously and ate a massive one regardless of what time zone he was in or if he had slept the night before. He always began the meal with Bloody Marys followed by margaritas.

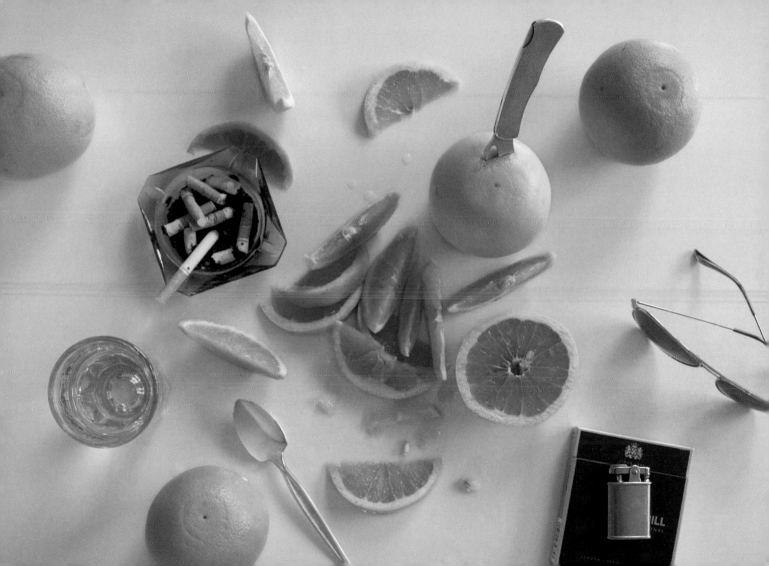

HEIDI

JOHANNA SPYRI, 1880

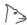

THE KETTLE SOON BEGAN TO BOIL, and meanwhile the old man held a large piece of cheese on a long iron fork over the fire, turning it round and round till it was toasted a nice golden yellow color on each side. Heidi watched all that was going on with eager curiosity.

- *Heidi* was originally published in two volumes, the first entitled *Heidi's Years of Learning and Travel* and the second, *Heidi Makes Use of What She Has Learned.*
- The 1937 movie—starring Shirley Temple in the title role—is perhaps the most beloved of the more than twenty film and television adaptations of *Heidi*.
- From the 1930s to 1999, the Swiss Cheese Union (Schweizerische Käseunion) promoted fondue and raclette—both forms of melted cheese served with bread—as the national dishes of Switzerland.

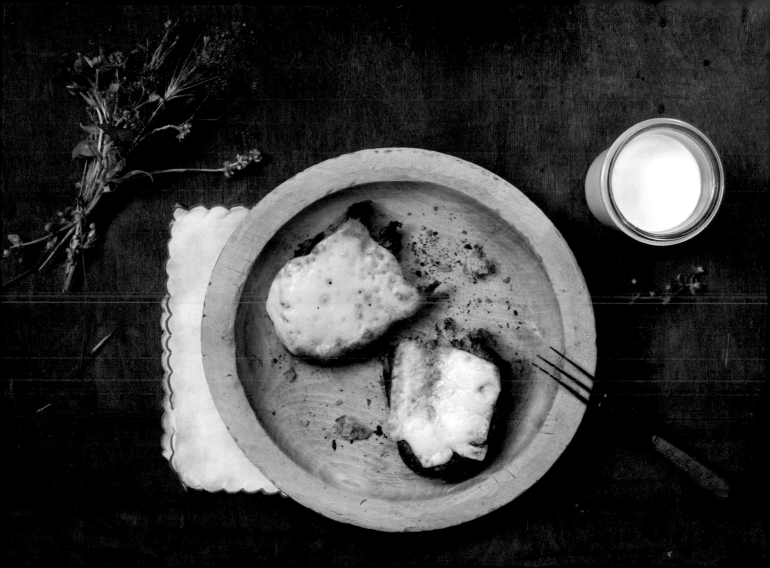

MIDDLESEX

JEFFREY EUGENIDES, 2002

MY GRANDFATHER'S SHORT EMPLOY AT THE FORD MOTOR COMPANY marked the only time any Stephanides has ever worked in the automotive industry. Instead of cars, we could become manufacturers of hamburger platters and Greek salads, industrialists of spanakopita and grilled cheese sandwiches, technocrats of rice pudding and banana cream pie. Our assembly line was the grill; our heavy machinery, the soda fountain.

- *Middlesex* was awarded the Pulitzer Prize for Fiction in 2003.
- Greek-owned diners, which have been popular in the United States since an immigration wave in the 1950s, often offer extensive menus that list a wide range of American and Greek dishes, from pancakes to gyro sandwiches, from disco fries to filet of sole, and from apple pie to spinach pie (spanakopita).
- Greek diners and coffee shops are renowned for serving coffee to go in now-iconic blue-and-white paper coffee cups, the design of which features two Greek vases and three steaming cups of coffee below the words WE ARE HAPPY TO SERVE YOU.
- In Greece, the average per capita feta cheese consumption per year is more than twenty-five pounds—the highest in the world.

EAST OF EDEN

JOHN STEINBECK, 1952

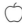

BECAUSE THE DAY HAD BEEN HOT, Lee set a table outside under an oak tree, and as the sun neared the western mountains he padded back and forth from the kitchen, carrying the cold meats, pickles, potato salad, coconut cake, and peach pie which were supper. In the center of the table he placed a gigantic stoneware pitcher full of milk.

- The summer meal described in the passage quoted here is eaten after newlyweds Adam and Cathy Trask first settle in California; he is ecstatically happy there, but she—pregnant with twin boys, Caleb and Aron—is not.
- A native of California's Salinas Valley himself, Steinbeck said that *East of Eden* was "the story of my country and the story of me." He considered *My Valley* as an alternative title for the novel.
- According to Steinbeck's records, he used approximately three hundred pencils and thirty-six reams of paper during the year he spent writing *East of Eden*.
- The word "pickle" comes from the Dutch word *pekel* ("brine"). According to the Department of Agriculture, the average American eats more than eight pounds of pickles a year.

THE METAMORPHOSIS

FRANZ KAFKA, 1915

IN ORDER TO TEST HIS TASTE, she brought him a whole selection of things, all spread out on an old newspaper. There were old, half-rotten vegetables; bones from the evening meal, covered in white sauce that had gone hard; a few raisins and almonds; some cheese that Gregor had declared inedible two days before; a dry roll and some bread spread with butter and salt....Then, out of consideration for Gregor's feelings, as she knew that he would not eat in front of her, she hurried out again and even turned the key in the lock so that Gregor would know he could make things as comfortable for himself as he liked. Gregor's little legs whirred, at last he could eat.... Quickly one after another, his eyes watering with pleasure, he consumed the cheese, the vegetables and the sauce; the fresh foods, on the other hand, he didn't like at all, and even dragged the things he did want to eat a little way away from them because he couldn't stand the smell.

- Kafka wrote *The Metamorphosis* in three weeks.
- In the book's original German, Gregor is transformed into an *ungeheures Ungeziefer*, which literally means "monstrous unclean animal not suitable for sacrifice." The English word "vermin" comes closest in meaning to the German word *Ungeziefer*, but it is often translated as "bug," "insect," "beetle," or "cockroach."
- After discovering her brother as a "vermin" for the first time, Grete Samsa goes out to get him some food and returns with a feast fit only for a fly.

At least 5 more books
might be published by
... gate.

Memorial ...
Celebrate ...
a Life ...

Is Said to Be Ne...

"BIG TWO-HEARTED RIVER"

ERNEST HEMINGWAY, 1925

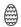

NICK WAS HUNGRY. He did not believe he had ever been hungrier. He opened and emptied a can of pork and beans and a can of spaghetti into a frying pan. . . .

The beans and spaghetti warmed. Nick stirred them and mixed them together. They began to bubble, making little bubbles that rose with difficulty to the surface. There was a good smell. Nick got out a bottle of tomato catchup and cut four slices of bread. The little bubbles were coming faster now. Nick sat down beside the fire and lifted the frying pan off. He poured about half the contents out into the tin plate. It spread slowly on the plate. Nick knew it was too hot. He poured on some tomato catchup. He knew the beans and spaghetti were still too hot. He looked at the fire, then at the tent, he was not going to spoil it all by burning his tongue. . . . He was very hungry. Across the river in the swamp, in the almost dark, he saw a mist rising. He looked at the tent once more. All right. He took a full spoonful from the plate.

- "Wholesome as they are good!" was the 1920s slogan for Campbell's Beans, which cost twelve cents a can at the time Hemingway wrote "Big Two-Hearted River."
- As a child, Hemingway spent much time hunting and fishing near his family's lake house in Michigan's Upper Peninsula, where he killed and ate trout, squirrels, and other woodland creatures.
- Hemingway loved to drink. His favorite cocktail was a dry martini, which he liked so ice cold that he had special methods for chilling it: he froze the martini glasses and the Spanish cocktail onions, and he made special giant ice cubes in tennis-ball cans.

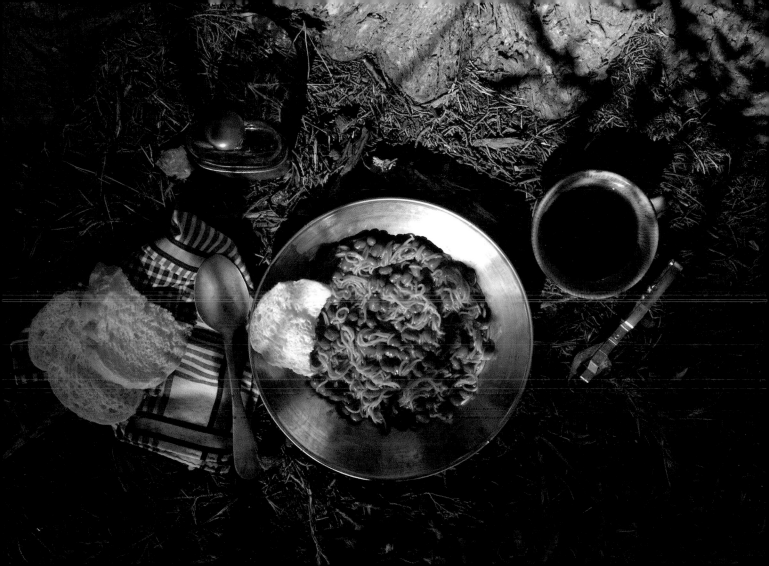

THE GIRL WITH THE DRAGON TATTOO

STIEG LARSSON, 2005

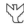

SHE IMPROVISED BANDAGES and covered the wound with a makeshift compress. Then she poured the coffee and handed him a sandwich.

"I'm really not hungry," he said.

"I don't give a damn if you're hungry. Just eat," Salander commanded, taking a big bite of her own cheese sandwich.

Blomkvist closed his eyes for a moment, then he sat up and took a bite. His throat hurt so much that he could scarcely swallow.

- Blomkvist and Lisbeth both have a large appetite for sandwiches. They consume between thirty and forty of them in the novel, and the word "sandwich" is mentioned in almost every one of the book's twenty-nine chapters.
- The Swedish word for open-faced sandwich is *smörgås*, which is composed of the words *smör* ("butter") and *gås* ("goose").
- Sandwiches in the novel are made with savory ingredients including cheese, dill pickles, caviar, hard-boiled egg, pickled herring, liver sausage, liver pâté, cucumbers, rye bread, mustard sauce, and chives.

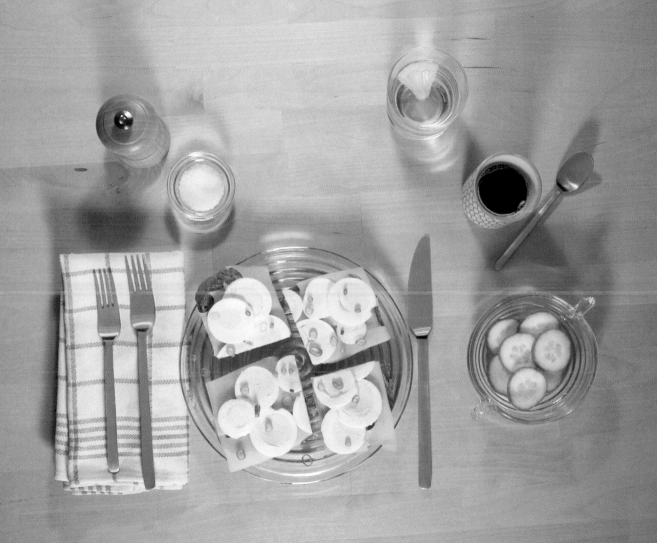

AMERICAN PSYCHO

BRET EASTON ELLIS, 1991

SHE DOESN'T SAY ANYTHING until we're seated at a mediocre table near the back section of the main dining room and that's only to order a Bellini. For dinner, I order the shad-roe ravioli with apple compote as an appetizer and the meat loaf with chèvre and quail-stock sauce for an entrée. She orders the red snapper with violets and pine nuts and for an appetizer a peanut butter soup with smoked duck and mashed squash which sounds strange but is actually quite good. *New York* magazine called it a "playful but mysterious little dish" and I repeat this to Patricia, who lights a cigarette while ignoring my lit match, sulkily slumped in her seat, exhaling smoke directly into my face, occasionally shooting furious looks at me which I politely ignore, being the gentleman that I can be. Once our plates arrive I just stare at my dinner—the meat loaf dark red triangles topped by chèvre which has been tinted pink by pomegranate juice, squiggles of thick tan quail stock circling the beef, and mango slices dotting the rim of the wide black plate—for a long time, a little confused, before deciding to eat it, hesitantly picking up my fork.

- The book's depiction of sexual violence toward women was so graphic that its original publisher, Simon & Schuster, withdrew from the project, citing aesthetic differences; subsequently, Vintage Books purchased the rights and published the novel.
- The first record of meatloaf is from *Apicius*, a Roman cookery collection, which dates to the fifth century A.D. The meatloaf recipe appears in the second section, *Sarcoptes* ("The Meat Mincer").

ANNE OF GREEN GABLES

LUCY MAUD MONTGOMERY, 1908

DIANA POURED HERSELF OUT A TUMBLERFUL, looked at its bright-red hue admiringly, and then sipped it daintily.

"That's awfully nice raspberry cordial, Anne," she said. "I didn't know raspberry cordial was so nice."

"I'm real glad you like it. Take as much as you want. I'm going to run out and stir the fire up. There are so many responsibilities on a person's mind when they're keeping house, isn't there?"

When Anne came back from the kitchen Diana was drinking her second glassful of cordial; and, being entreated thereto by Anne, she offered no particular objection to the drinking of a third. The tumblerfuls were generous ones and the raspberry cordial was certainly very nice.

- Thinking she's serving raspberry cordial, Anne inadvertently intoxicates her "bosom friend," Diana Barry, by giving her currant wine.
- Raspberry cordial is a sweet drink made from crushed raspberries, sugar, and lemon juice.
- The novel is extremely popular in Japan, and Japanese fans often have Anne-themed weddings, with the brides wearing red wigs. The Japanese post office has even issued an anime Anne postage stamp.
- The real Green Gables house is a major tourist attraction on Prince Edward Island, as is the Avonlea Village theme park, where people dress up as Anne, Diana, and other characters from the Avonlea series.

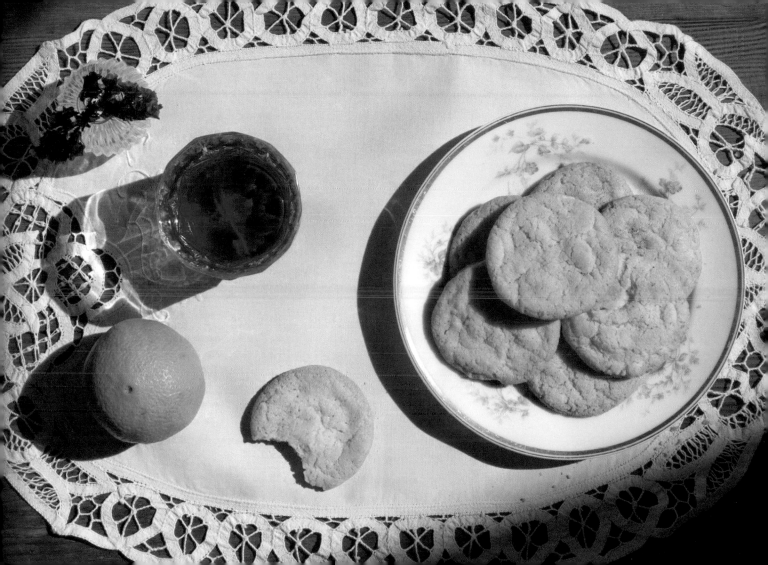

THE BELL JAR

SYLVIA PLATH, 1963

THEN I TACKLED THE AVOCADO AND CRABMEAT SALAD. Avocados are my favorite fruit. Every Sunday my grandfather used to bring me an avocado pear hidden at the bottom of his briefcase under six soiled shirts and the Sunday comics. He taught me how to eat avocados by melting grape jelly and french dressing together in a saucepan and filling the cup of the pear with the garnet sauce. I felt homesick for that sauce. The crabmeat tasted bland in comparison.

- After winning a prestigious internship at *Ladies' Day* magazine, Esther attends a welcome luncheon hosted by the magazine and stuffs herself with delicacies like caviar and crabmeat-filled avocados, only to regret it later when she and her fellow diners get violently ill from food poisoning.
- *The Bell Jar* was Plath's only novel.
- Like Esther, Plath struggled with mental illness. She committed suicide at age thirty, a month after the publication of *The Bell Jar*.
- Native to central Mexico, avocados may date back as early as 8000 B.C. and were cultivated by 1200 B.C. They were introduced in the United States in 1871, when three trees were planted in Santa Barbara, California.

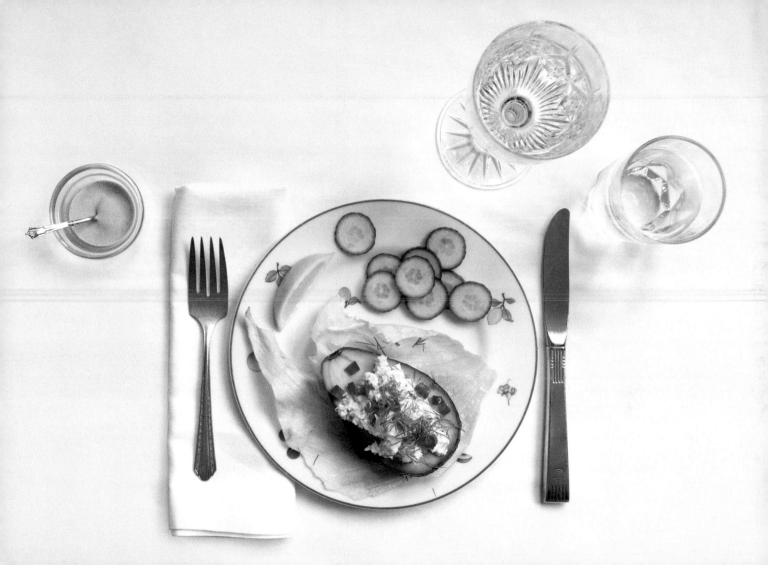

OLIVER TWIST

CHARLES DICKENS, 1837

CHILD AS HE WAS, HE WAS DESPERATE WITH HUNGER, and reckless with misery. He rose from the table; and advancing to the master, basin and spoon in hand, said: somewhat alarmed at his own temerity:

"Please, sir, I want some more."

The master was a fat, healthy man; but he turned very pale. He gazed in stupefied astonishment on the small rebel for some seconds, and then clung for support to the copper. The assistants were paralysed with wonder; the boys with fear.

"What!" said the master at length, in a faint voice.

"Please, sir," replied Oliver, "I want some more."

The master aimed a blow at Oliver's head with the ladle; pinioned him in his arm; and shrieked aloud for the beadle.

- Because Oliver asks for a second serving of gruel, he is sold into a terrible apprenticeship with an undertaker.
- *Oliver Twist*'s realistic images of poverty, crime, and injustice shocked its readers upon its publication; Dickens wrote the novel with the intention of shedding light on the grim and inescapable fates assigned to the poor, of which many of his middle-class readers were ignorant.
- Dating back to ancient Greece, gruel—a thin porridge made by boiling oats, rye, wheat, or rice with water or milk—has long been a staple food of peasants in the Western world.

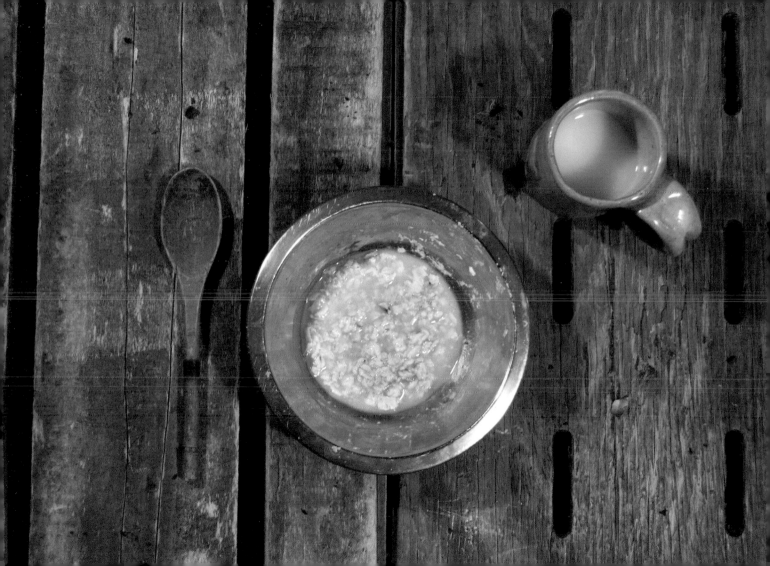

ALICE'S ADVENTURES IN WONDERLAND

LEWIS CARROLL, 1865

THE TABLE WAS A LARGE ONE, but the three were all crowded together at one corner of it:

"No room! No room!" they cried out when they saw Alice coming.

"There's plenty of room!" said Alice indignantly, and she sat down in a large arm-chair at one end of the table.

"Have some wine," the March Hare said in an encouraging tone.

Alice looked all round the table, but there was nothing on it but tea. "I don't see any wine," she remarked.

"There isn't any," said the March Hare.

"Then it wasn't very civil of you to offer it," said Alice angrily.

"It wasn't very civil of you to sit down without being invited," said the March Hare.

- Lewis Carroll (pen name of Charles Lutwidge Dodgson) first told the fantastical story to the three young daughters of his friend Henry Liddell, to entertain them in a rowboat; months later, Carroll gave the middle daughter, ten-year-old Alice, a manuscript of the tale called *Alice's Adventures Under Ground*.
- Carroll's original manuscript was illustrated with the author's own sketches, although it is Sir John Tenniel's forty-two wood-cut engravings for the first published edition, *Alice's Adventures in Wonderland* (1865), that most readers associate with the book.
- Alice has been used for more than a century to sell products—from Wonder Bread and Philco refrigerators to vacations in Yellowstone Park.

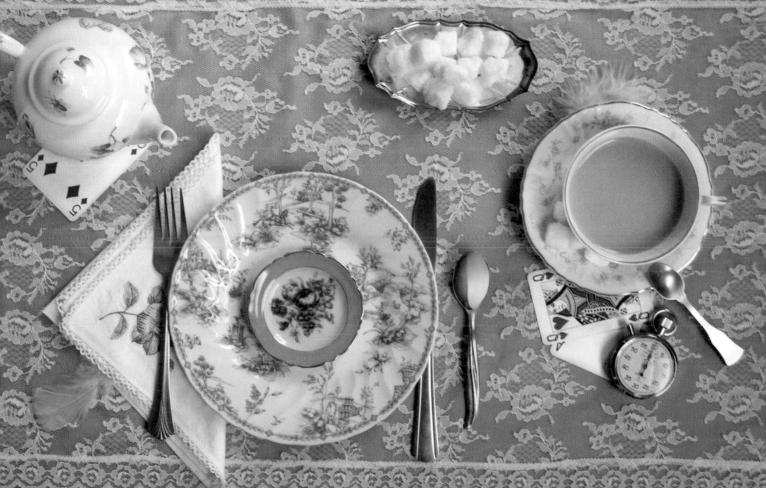

THE AMAZING ADVENTURES OF KAVALIER AND CLAY

MICHAEL CHABON, 2000

HERE THEY FOUND and proceeded to devour a light supper consisting of the thrice-picked-over demi-carcass of a by now quite hoary chicken, nine soda crackers, one sardine, some milk, as well as a yellow doorstop of adamantine cheese they found wedged, under the milk bottle, between the slats of the shelf outside the window.

- *The Amazing Adventures of Kavalier and Clay* won the Pulitzer Prize for Fiction in 2001.
- Soda crackers—or saltines—were first made by the F. L. Sommer & Company in 1886, when Sommer began using baking soda to leaven thin crackers; the result was so popular that his business quadrupled in less than four years.
- Sardines are considered a "superfood," as they are full of omega-3 fatty acids, vitamin B, iron, calcium, and protein.

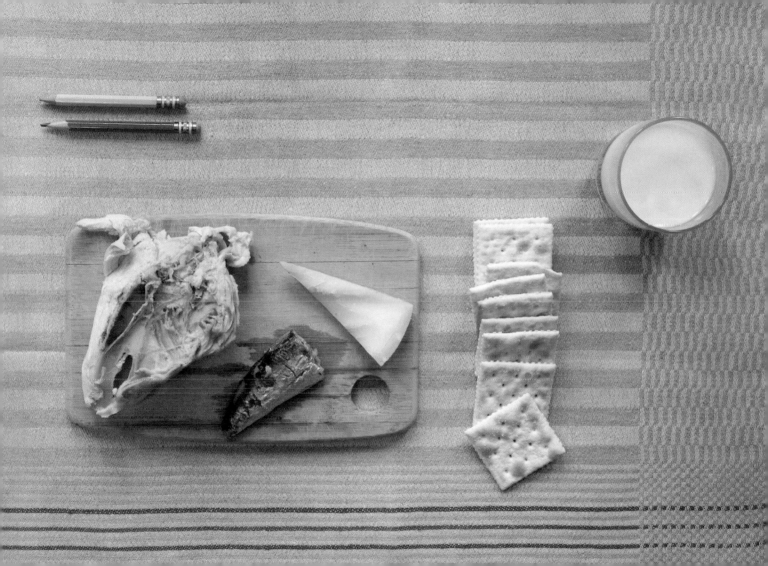

BREAD AND JAM FOR FRANCES

RUSSELL HOBAN, 1964

"WELL," SAID FRANCES, LAYING A PAPER DOILY ON HER DESK and setting a tiny vase of violets in the middle of it, "let me see." She arranged her lunch on the doily.

"I have a thermos bottle with cream of tomato soup," she said.

"And a lobster-salad sandwich on thin slices of white bread.

"I have celery, carrot sticks, and black olives, and a little cardboard shaker of salt for the celery.

"And two plums and a tiny basket of cherries.

"And vanilla pudding with chocolate sprinkles and a spoon to eat it with."

- This special meal comes at the end of the book, after Frances's eyes are opened to the culinary world beyond bread and jam.
- Welch's created modern jam in 1918 during World War I for US Army rations, calling it "Grapelade." The Army bought Welch's first production run, and soldiers liked it so much they demanded it after they returned to civilian life. Welch's launched retail Concord Grape Jelly in 1923.
- Hoban wrote seven books about Frances the badger, and many of her adventures were inspired by the lives of his four children, Phoebe, Brom, Esmé, and Julia.
- *Bedtime for Frances*, the first of the Frances books, was illustrated by Garth Williams, the celebrated children's book illustrator of *Charlotte's Web*, *Stuart Little*, and the Little House series. The other six were illustrated by Lillian Hoban, Russell's wife for thirty years.

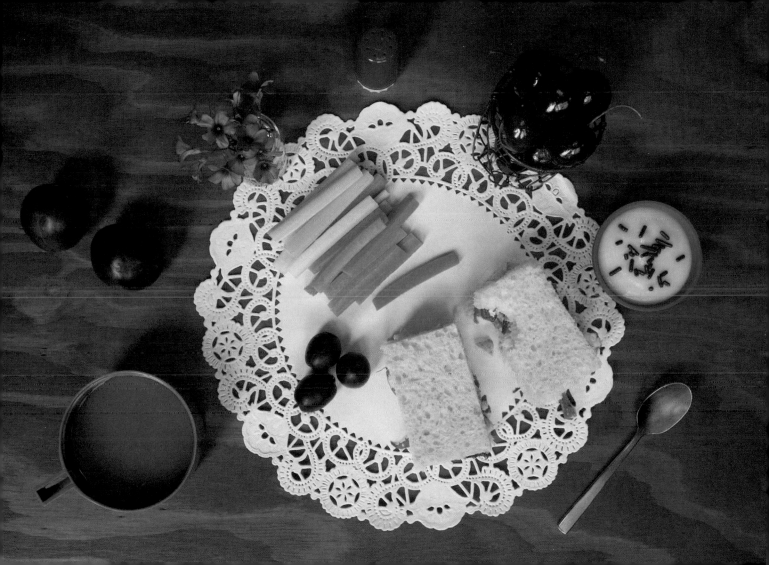

HEARTBURN

NORA EPHRON, 1983

RICE PUDDING IS THE ONLY THING ARTHUR COOKS but he cooks it perfectly, with exactly the right proportion of rice to raisins. There's an awful lot of nursery food in this book already so I won't give you the recipe. My feeling about rice pudding is that if you like it, you already have a good recipe; and if you don't there's no way anyone will ever get you to eat it, unless you fall in love with someone who likes rice pudding, which I once did, and then you learn to love it, too.

- The novel is loosely based on Ephron's personal experience, when she discovered that her husband, journalist Carl Bernstein, was committing adultery.
- When Rachel realizes that her husband will never change and that the marriage is over, she throws a key lime pie in his face.
- Her marriage over, and having just given birth to her soon-to-be ex-husband's child, vulnerable Rachel is comforted by a visit from friends Julie and Arthur, who bring rice pudding to her hospital room.
- Rice pudding is a simple dish of cooked rice and milk, often mixed with other ingredients such as cinnamon and raisins; some version of it exists in almost every country. A few of the many variations include *m'halbi* (in Algeria), *roz be laban* (Egypt), *kiribath* (Sri Lanka), *moghli* (Lebanon), *sütlaç* (Turkey), *grjónagrautur* (Iceland), *risengrød* (Denmark), *riz au lait* (France), and *arroz con leche* (many Spanish-speaking countries).

THE GREAT GATSBY

F. SCOTT FITZGERALD, 1925

AT LEAST ONCE A FORTNIGHT A CORPS OF CATERERS came down with several hundred feet of canvas and enough colored lights to make a Christmas tree of Gatsby's enormous garden. On buffet tables, garnished with glistening hors-d'oeuvre, spiced baked hams crowded against salads of harlequin designs and pastry pigs and turkeys bewitched to a dark gold. In the main hall a bar with a real brass rail was set up, and stocked with gins and liquors and with cordials so long forgotten that most of his female guests were too young to know one from another.

- Many titles were in the running for this novel: *The High Bouncing Lover*; *Under the Red, White, and Blue*; *Trimalchio*; *Among Ash-Heaps and Millionaires*; *Gold-hatted Gatsby*; and others. Fitzgerald was never satisfied with his final choice of title.
- *The Great Gatsby* was written and set in the Prohibition Era, a time rife with illegal bootleggers and speakeasies, a period that Fitzgerald memorably dubbed "the Jazz Age."
- The novel's iconic blue cover featuring two disembodied eyes was painted by little-known artist Francis Cugat while Fitzgerald was still writing the book. It is said that the author loved the image so much that he wrote the eyes into his narrative, as the picture on the iconic fading billboard featuring the eyes of Doctor T. J. Eckleburg.
- According to the American Farm Bureau Foundation, "pastry pigs" should be celebrated on April 24—National Pig-in-a-Blanket Day—which honors this party favorite: small sausages wrapped in biscuit dough.

GRAVITY'S RAINBOW

THOMAS PYNCHON, 1973

NOW THERE GROWS among all the rooms, replacing the night's old smoke, alcohol and sweat, the fragile, musaceous odor of Breakfast. . . . Pirate's mob gather at the shores of the great refectory table, a southern island well across a tropic or two from chill Corydon Throsp's medieval fantasies, crowded now over the swirling dark grain of its walnut uplands with banana omelets, banana sandwiches, banana casseroles, mashed bananas molded in the shape of a British lion rampant, blended with eggs into batter for French toast. . .tall cruets of pale banana syrup to pour oozing over banana waffles, a giant glazed crock where diced bananas have been fermenting since the summer with wild honey and muscat raisins, up out of which, this winter morning, one now dips foam mugsfull of banana mead…banana croissants and banana kreplach, and banana oatmeal and banana jam and banana bread, and bananas flamed in ancient brandy Pirate brought back last year from a cellar in the Pyrenees also containing a clandestine radio transmitter. . . .

- The word *banana* comes from the Arabic word *banan*, which means "finger"; consequently, a single banana is often referred to as a "finger" and a bunch of bananas is called a "hand."
- In the novel, Captain Geoffrey "Pirate" Prentice, yearning for bananas during a wartime shortage, builds a rooftop greenhouse, where he plants his own banana trees.
- Bananas are the world's fourth most popular agricultural crop (after wheat, rice, and corn), with over 100 billion eaten yearly.

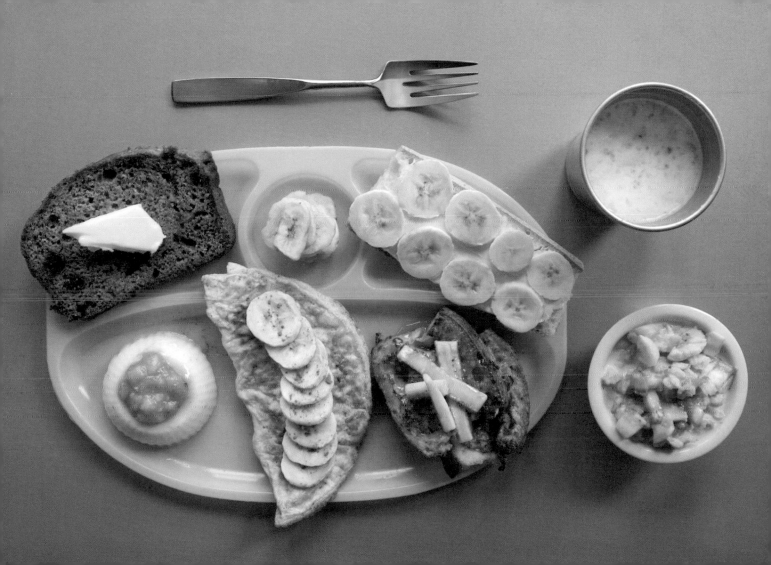

A CONFEDERACY OF DUNCES

JOHN KENNEDY TOOLE, 1980

STOPPING BEFORE THE NARROW GARAGE, he sniffed the fumes from Paradise with great sensory pleasure, the protruding hairs in his nostrils analyzing, cataloging, categorizing, and classifying the distinct odors of the hot dog, mustard, and lubricant. Breathing deeply, he wondered also if he detected the more delicate odor, the fragile scent of hot dog buns. He looked at the white-gloved hands of his Mickey Mouse wristwatch and noticed that he had eaten lunch only an hour before. Still the intriguing aromas were making him salivate actively.

- Published eleven years after Toole's suicide, *A Confederacy of Dunces* earned the author a posthumous Pulitzer Prize for Fiction in 1981.
- The frankfurter originated as a pork sausage similar to the hot dog in the thirteenth century in Frankfurt, Germany, where it was given out during imperial coronation celebrations.
- The origin of the hot dog in the United States is often credited to Charles Feltman, a German immigrant who began serving sausages in buns from his pie wagon on the Coney Island boardwalk in the 1870s.
- Devouring sixty-nine hot dogs in buns in ten minutes at the 98th Annual Nathan's Hot Dog Eating Contest in Coney Island in 2013, competitive eater Joseph Christian "Jaws" Chestnut won for the seventh time in a row and currently holds the world record for hot dog consumption.

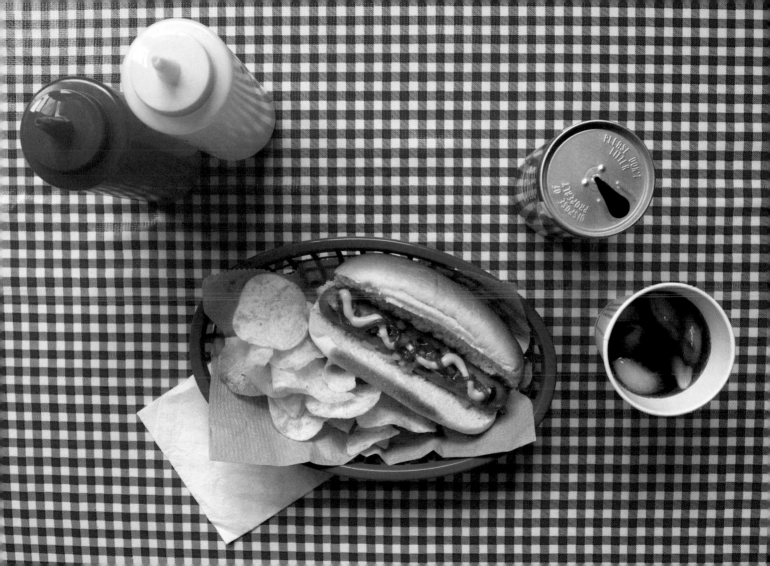

TO THE LIGHTHOUSE

VIRGINIA WOOLF, 1927

WHEN THERE ARE FIFTEEN PEOPLE SITTING DOWN TO DINNER, one cannot keep things waiting for ever. She was now beginning to feel annoyed with them for being so late; it was inconsiderate of them, and it annoyed her on top of her anxiety about them, that they should choose this very night to be out late, when, in fact, she wished the dinner to be particularly nice, since William Bankes had at last consented to dine with them; and they were having Mildred's masterpiece—Boeuf en Daube. Everything depended upon things being served up to the precise moment they were ready. The beef, the bayleaf, and the wine—all must be done to a turn. To keep it waiting was out of the question. Yet of course tonight, of all nights, out they went, and they came in late, and things had to be sent out, things had to be kept hot; the Boeuf en Daube would be entirely spoilt.

- The first edition of Woolf's beloved modernist novel was printed at the Hogarth Press, the printing house in London that she owned with her husband, Leonard Woolf. The original dust jacket was illustrated by Woolf's sister, painter Vanessa Bell.
- Woolf believed that *To the Lighthouse* was "easily the best of my books."
- *Boeuf en daube* is a classic French stew made with beef braised in wine and herbes de Provence; it sometimes includes olives, prunes, juniper berries, or orange peel. It is traditionally cooked in a *daubière*, a type of terra-cotta pot used to cook food over a flame.

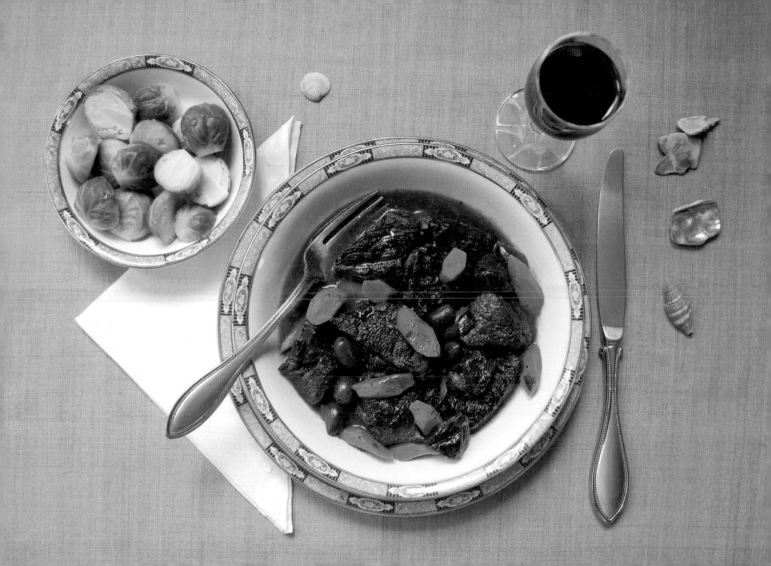

THE TALE OF PETER RABBIT

BEATRIX POTTER, 1902

I AM SORRY TO SAY THAT PETER WAS NOT VERY WELL during the evening. His mother put him to bed, and made some camomile tea; and she gave a dose of it to Peter!

"One table-spoonful to be taken at bed-time."

But Flopsy, Mopsy, and Cotton-tail had bread and milk and blackberries for supper.

- The story ends with Mrs. Rabbit putting a sick Peter to bed and feeding his three sisters a special dinner of the blackberries they picked that day.
- Before writing books, Potter wrote charming "picture letters" to the children of her former governess, Annie Moore. On Moore's suggestion, she expanded the letters into books and so began her publishing career.
- Potter wrote and illustrated twenty-three tales about anthropomorphized animals living in the British countryside, many of which were based on her real-life pets—her pet rabbit was named Peter Piper.
- Chamomile, long used in herbal medicine, is believed to settle an upset stomach, quell anxiety, and promote restful sleep.
- Blackberries also have medicinal benefits: ancient Greeks ate the roots, leaves, and berries to cure gout; during the Civil War, blackberry tea was believed to cure dysentery; and because the berries are full of antioxidants, they are believed to help prevent certain types of cancer.

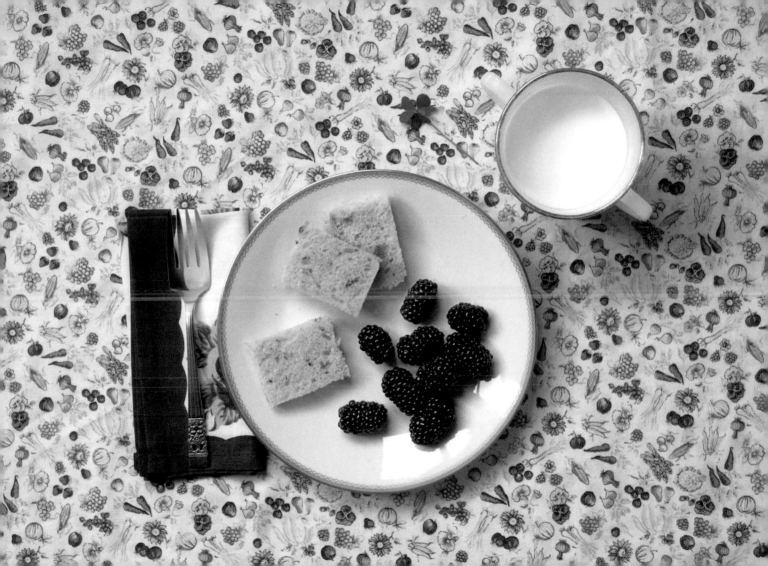

THE LION, THE WITCH AND THE WARDROBE

C. S. LEWIS, 1950

THE QUEEN LET ANOTHER DROP FALL from her bottle onto the snow, and instantly there appeared a round box, tied with green silk ribbon, which, when opened, turned out to contain several pounds of the best Turkish Delight. Each piece was sweet and light to the very center and Edmund had never tasted anything more delicious.

- Turkish delight, believed to have been invented in Constantinople in 1776 by a confectioner named Bekir Effendi in 1776, is a type of gel candy made with dried fruit and nuts and often flavored with rose water or citrus; it is usually served cut into squares and dusted with powdered sugar.
- The sweet treat, which quickly became popular throughout Europe and a delicacy of the upper class, was often given as a gift wrapped in a silk handkerchief.
- *The Chronicles of Narnia* is full of wonderful food descriptions throughout, beginning when Lucy first wanders into Narnia and has delicious tea, soft-boiled eggs, sardines on toast, and sugar-topped cake with a faun named Mr. Tumnus. In fact, there are several cookbooks that attempt to provide interpretations of the food described in the story.
- Lewis, an atheist from the age of fifteen, slowly changed his mind in the years after returning home wounded in 1918 during World War I; he converted to Christianity in 1931. *The Lion, the Witch and the Wardrobe* is thought by many to be a distinct allegory for his new religious beliefs.

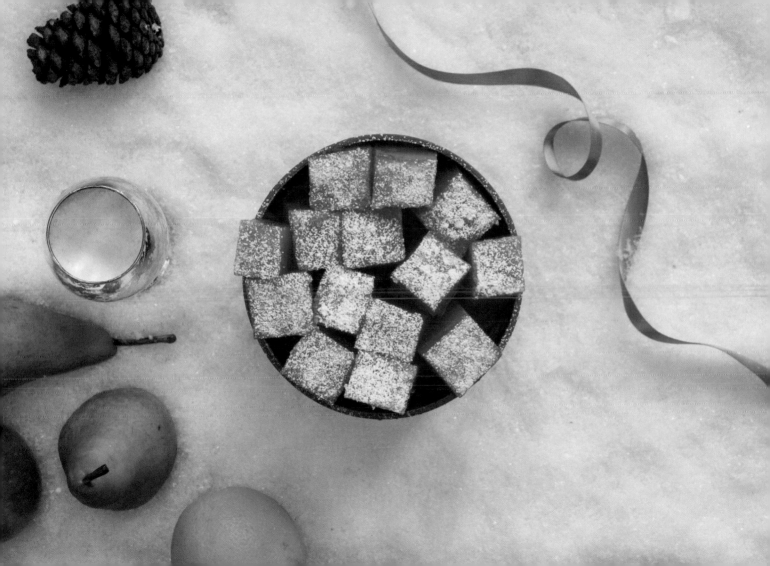

MOTHERLESS BROOKLYN

JONATHAN LETHEM, 1999

"MAUFISHFUL" SAID GILBERT CONEY in response to my outburst, not even turning his head. I could barely make out the words—"My mouth is full"—both truthful and a joke, lame. Accustomed to my verbal ticcing, he didn't usually bother to comment. Now he nudged the bag of White Castles in my direction on the car seat, crinkling the paper. "Stuffinyahole."

Coney didn't rate any special consideration from me. "Eatmeeatmeeatme," I shrieked again, letting off more of the pressure in my head. Then I was able to concentrate. I helped myself to one of the tiny burgers. Unwrapping it, I lifted the top of the bun to examine the grid of holes in the patty, the slime of glistening cubed onions. This was another compulsion. I always had to look inside a White Castle, to appreciate the contrast of machine-tooled burger and nubbin of fried goo. Kaos and control. Then I did more or less as Gilbert had suggested—pushed it into my mouth whole. The ancient slogan *Buy 'em by the sack* humming deep in my head, jaw working to grind the slider into swallowable chunks, I turned back to stare out the window at the house.

Food really mellows me out.

- White Castle was founded in 1921 by Edgar Waldo "Billy" A. Ingram and Walt A. Anderson. In addition to making the chain's signature square "sliders," Anderson invented paper-wrapped burgers and the paper hats worn by servers.
- The novel won the 1999 National Book Critics Circle Award for fiction and the 2000 Gold Dagger award for crime fiction.

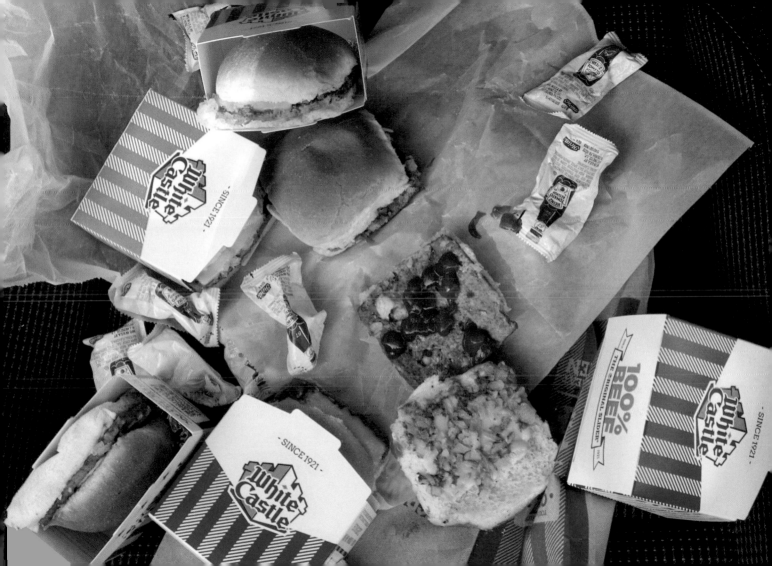

EMMA

JANE AUSTEN, 1815

THESE WERE PLEASANT FEELINGS, and she walked about and indulged them till it was necessary to do as the others did, and collect round the strawberry-beds. . . and Mrs. Elton, in all her apparatus of happiness, her large bonnet and her basket, was very ready to lead the way in gathering, accepting, or talking—strawberries, and only strawberries, could now be thought or spoken of.—"The best fruit in England—every body's favourite—always wholesome.—These the finest beds and finest sorts.—Delightful to gather for one's self—the only way of really enjoying them. . . white wood finest flavour of all—price of strawberries in London—abundance about Bristol. . . no general rule—gardeners never to be put out of their way—delicious fruit—only too rich to be eaten much of—inferior to cherries—currants more refreshing—only objection to gathering strawberries the stooping—glaring sun—tired to death—could bear it no longer—must go and sit in the shade."

• Despite proposals, Austen never married, setting her apart from many of her novels' characters, who are husband hunters.

• Strawberries are not technically berries, as their seeds—about two hundred on each—are on the outside of the fruit.

• Strawberries have long been associated with flirtation, love, and sex. An old French tradition is for newlyweds to eat a breakfast of strawberry soup—made with sour cream, powdered sugar, and borage (starflower)—to celebrate their love.

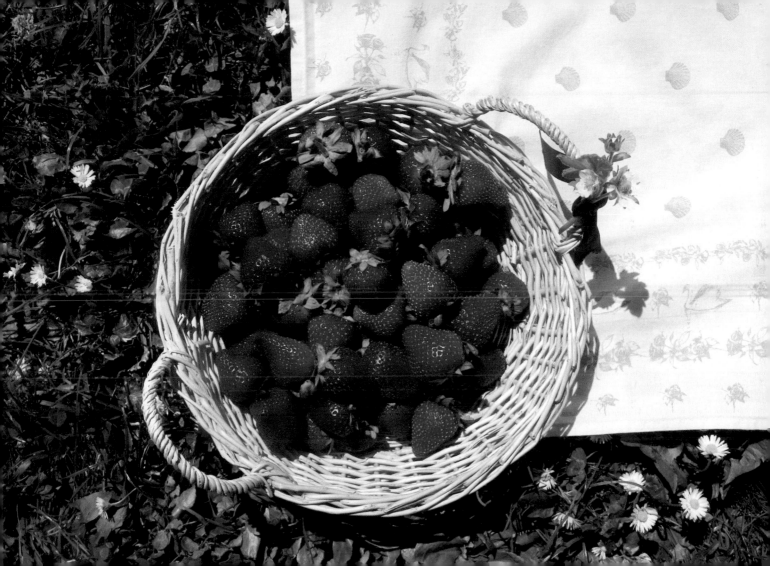

VALLEY OF THE DOLLS

JACQUELINE SUSANN, 1965

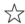

SHE WALKED INTO THE BATHROOM and took a red pill—she had taken one every night for a week until Lyon had returned. She had the feeling that it had been the only thing that had saved her sanity. She hadn't taken one since his return. But here we go again, she thought. Thank God for the lovely red dolls. They made the nights bearable.

- A guilty pleasure for many of its readers, *Valley of the Dolls* has a cult following and has sold more than thirty million copies since its publication. It's one of the top-ten bestselling books of all time.
- The "dolls" in the title is a slang term for sleeping pills; "doll" was originally a shortened form of the medication dolophine (methadone), but ultimately it referred to any type of barbiturate.
- Before her writing career began, Susann pursued acting and is said to have had several romantic relationships with celebrities—both men and women—which are chronicled in her novels.
- Though never confirmed by Susann, many of the novel's characters are rumored to be based on real-life celebrities—alcoholic Neely on Judy Garland; tragic Jennifer on both Marilyn Monroe and Carole Landis; and bawdy Helen Lawson on Ethel Merman.

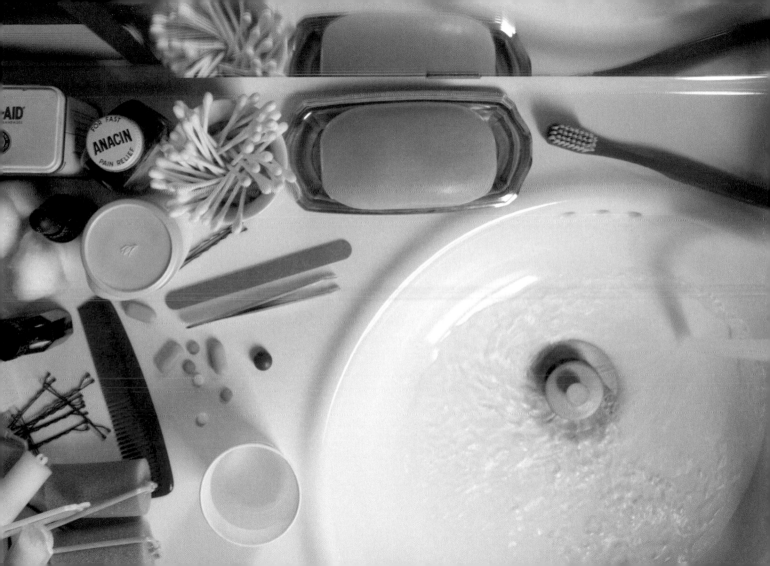

ULYSSES

JAMES JOYCE, 1922

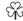

MR LEOPOLD BLOOM ATE WITH RELISH the inner organs of beasts and fowls. He liked thick giblet soup, nutty gizzards, a stuffed roast heart, liverslices fried with crustcrumbs, fried hencod's roes. Most of all he liked grilled mutton kidneys which gave to his palate a fine tang of faintly scented urine.

- *Ulysses* takes place on June 16, 1904, the day when Joyce and Nora Barnacle, his future wife, first went out together.
- A holiday commemorating Joyce takes place every year on June 16 in Ireland, Europe, the United States, and beyond; it is called Bloomsday (named after protagonist Leopold Bloom). Fans and readers of Joyce celebrate with readings, performances, pub crawls, and other activities.
- Bloom has a lucky potato, which he carries in his pocket.
- Bloom drinks his tea out of a moustache cup that his daughter, Milly, gave him for his twenty-seventh birthday. Invented in the 1860s and popular during the late Victorian era, the moustache cup has a semicircular ledge that extends across part of the cup's opening and keeps the user's moustache from getting wet while he drinks.

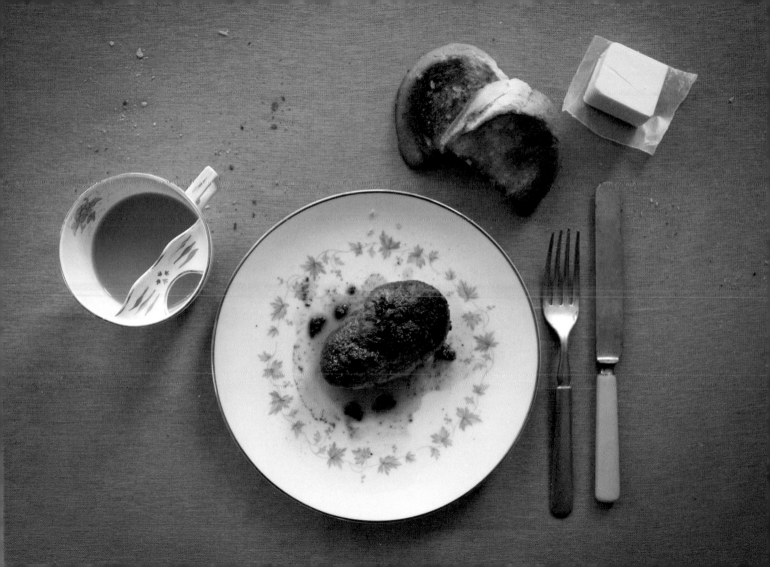

BOOK SUMMARIES

The Adventures of Huckleberry Finn, Mark Twain, 1884. This classic follows the exploits of the title character as he sails down the Mississippi River on a makeshift raft with a slave boy named Jim.

Alice's Adventures in Wonderland, Lewis Carroll, 1865. The fantastical experiences of young Alice, who follows a white rabbit with a pocket watch in his waistcoat, only to fall down a deep hole to arrive at a strange place called Wonderland.

The Amazing Adventures of Kavalier and Clay, Michael Chabon, 2000. The tale of two cousins who team up to create comic books together in New York City in the 1940s.

American Psycho, Bret Easton Ellis, 1991. The chilling story of Patrick Bateman, a wealthy young Wall Street investment banker turned serial killer in the late 1980s.

Anne of Green Gables, Lucy Maud Montgomery, 1908. The adventures and mishaps of Anne Shirley, an independent-minded red-headed orphan with a hot temper, living on a farm in Avonlea on Prince Edward Island, Canada.

Beezus and Ramona, Beverly Cleary, 1955. The first of the Ramona book series, this children's book tells the story of Beatrice "Beezus" Quimby and her pesky four-year-old sister, Ramona.

The Bell Jar, Sylvia Plath, 1963. The semiautobiographical novel about Esther Greenwood, a promising young woman who struggles with depression and descends into crippling mental illness.

"Big Two-Hearted River," Ernest Hemingway, 1925. In this short story, soldier Nick Adams returns to the remote place on Michigan's Upper Peninsula where he used to go fishing before he served in World War I.

Blueberries for Sal, Robert McCloskey, 1948. Set in a town in Maine, this children's picture book tells the story of a little girl named Sal who goes blueberry picking with her mother and encounters a mother bear and cub engaged in the same activity.

The Bluest Eye, Toni Morrison, 1970. A year in the life of Pecola Breedlove—an African American girl living in Lorain, Ohio, in 1941—as she faces racism and struggles with an inferiority complex as a result.

Bread and Jam for Frances, Russell Hoban, 1964. Beloved by picky and non-picky eaters alike, this children's classic is about a young badger who decides she will eat nothing but bread and jam until, one day, she tires of it after having it for the sixth meal in a row.

The Catcher in the Rye, J. D. Salinger, 1951. A quintessential coming-of-age novel related mostly in the first person by the famous protagonist, teenager Holden Caulfield, after his expulsion from yet another prep school.

"Chicken Soup with Rice," Maurice Sendak, 1962. A delightful children's poem that celebrates eating chicken soup with rice every month of the year.

A Confederacy of Dunces, John Kennedy Toole, 1980. The comic story of Ignatius J. Reilly, a slovenly thirty-year-old ne'er-do-well who lives with his mother in New Orleans.

The Corrections, Jonathan Franzen, 2001. This novel relates the intertwined stories of the Lamberts, a dysfunctional and repressed Midwestern family—as they prepare to spend "one last Christmas" together in their Ohio home.

East of Eden, John Steinbeck, 1952. Inspired by the story of Cain and Abel, this book tells the enmeshed stories of two California families, the Trasks and the Hamiltons, and examines humankind's perpetual struggle between good and evil.

Emma, Jane Austen, 1815. Austen's classic chronicles the exploits of wealthy twenty-year-old Emma Woodhouse, who has sworn off marriage yet fancies herself a talented matchmaker for others.

Fear and Loathing in Las Vegas, Hunter S. Thompson, 1971. The story of Raoul Duke (a loosely veiled version of Thompson himself) and his lawyer, Dr. Gonzo, as they make their drug-addled way to Las Vegas on assignment for *Sports Illustrated* and instead binge on recreational drugs.

The Girl with the Dragon Tattoo, Stieg Larsson, 2005. The story of journalist Mikael Blomkvist, who teams up with computer hacker Lisbeth Salander to catch a serial killer in Sweden.

Gone with the Wind, Margaret Mitchell, 1936. The saga of a proud, rich, and beautiful Southern belle, Scarlett O'Hara, and her romantic liaisons with Ashley Wilkes and Rhett Butler during the Civil War and Reconstruction.

Gravity's Rainbow, Thomas Pynchon, 1973. Narrative and character shatter as Tyrone Slothrop, a US Army lieutenant, travels deeper into Europe during World War II to uncover the secret of the Nazis' classified new rocket (the V-2) in this complex and experimental novel.

The Great Gatsby, F. Scott Fitzgerald, 1925. The story of the fabulously wealthy Jay Gatsby and his pursuit of the American Dream in the Roaring Twenties.

Gulliver's Travels, Jonathan Swift, 1726. A satire that recounts the sea adventures of Lemuel Gulliver, whose journey takes him to various unusual and outlandish places.

Heartburn, Nora Ephron, 1983. Rachel Samstedt, a cookbook writer who discovers that her husband, Mark, is having an affair, humorously relates how she copes with the aftermath.

Heidi, Johanna Spyri, 1880. The tale of a cheerful and selfless orphan girl sent by an uncaring aunt to the top of a mountain in the Swiss Alps to live with her reclusive grandfather.

Hopscotch, Julio Cortázar, 1963. The story of Horacio Oliviera and his lover, who live in Paris and refuse to plan their encounters, instead waiting for coincidence to align them in time and place; and later what happens when Horacio returns to Buenos Aires and reconnects with his childhood friend Manolo Traveler.

The Lion, the Witch and the Wardrobe, C. S. Lewis, 1950. The first novel in C. S. Lewis's seven-volume series, The Chronicles of Narnia, follows the adventures of four children—siblings Peter, Susan, Edmund, and Lucy—who stumble upon an enchanted wardrobe that leads them into the magical land of Narnia.

Little Women, Louisa May Alcott, 1868–69. The coming-of-age story of the four March sisters—Meg, Jo, Beth, and Amy—in Concord, Massachusetts, in the late 1800s, relating their daily activities, financial difficulties, family emergencies, illnesses, and love interests.

Lolita, Vladimir Nabokov, 1955. This celebrated and controversial novel is the story of the unruly obsession and subsequent love affair of a middle-aged professor, Humbert Humbert, with his twelve-year-old stepdaughter.

Madame Bovary, Gustave Flaubert, 1856. The story of a doctor's wife who, disenchanted with her life and her dull husband, attempts to alleviate her boredom through two affairs that end badly.

The Metamorphosis, Franz Kafka, 1915. The novel's protagonist, Gregor Samsa, wakes up one morning to find that he has been transformed into a huge insect.

Middlesex, Jeffrey Eugenides, 2002. A Greek family saga, whose protagonist, Callie Stephanides (later Cal), learns at the age of fourteen that she is a hermaphrodite, due to a genetic anomaly.

Moby-Dick; or The Whale, Herman Melville, 1851. The story of a sailor, Ishmael, and his voyage on a whale ship, whose captain, Ahab, is seeking revenge on the white whale Moby-Dick, which destroyed his boats and bit off his leg on a previous voyage.

Motherless Brooklyn, Jonathan Lethem, 1999. This novel follows Lionel Essrog, a Brooklyn detective with Tourette's syndrome, as he attempts to solve the murder of someone close to his heart.

The Namesake, Jhumpa Lahiri, 2003. The story of a Bengali couple, Ashoke and Ashima Ganguli, and their son, Nikhil, as they struggle to assimilate and define their cultural identity in the United States.

Oliver Twist, Charles Dickens, 1837. A rags-to-riches story about an orphan boy, born on the streets to a nameless mother, who has one harrowing experience after another until his fate changes for the better.

On the Road, Jack Kerouac, 1957. This Beat novel is a winding narrative by Sal Paradise of the three years he spends traveling across the United States, chronicling his reckless adventures with free-spirited Dean Moriarty.

One Hundred Years of Solitude, Gabriel García Márquez, 1967. A mystical and layered tale, this book tells the history of the town of Macondo and of several generations of the Buendía family, who founded it, and the misfortunes that befall them over a period of a hundred years.

Rebecca, Daphne du Maurier, 1938. The gothic tale of a young woman who marries the wealthy Maxim de Winter, only to find that he is still haunted by the death of his first wife, Rebecca.

Robinson Crusoe, Daniel Defoe, 1719. This classic details the experiences of a sole survivor of a shipwreck in the Caribbean and his life on a remote island near Trinidad.

The Road, Cormac McCarthy, 2006. A postapocalyptic story of a man and his son making a difficult journey south toward the Gulf Coast after an unspecified catastrophe has ravaged the Earth.

The Secret Garden, Frances Hodgson Burnett, 1910–11. This children's novel tells the story of the ill-tempered orphan Mary Lennox—sent from India to her uncle's gloomy Yorkshire mansion—who is transformed when she discovers there her invalid cousin, Colin, and an abandoned garden, then restores them both to good health.

Swann's Way, Marcel Proust, 1913. The first of seven volumes of Marcel Proust's *In Search of Lost Time* (*À la recherche du temps perdu*), known for its theme of involuntary memory, follows the life of the Narrator, whose name is never disclosed.

The Tale of Peter Rabbit, Beatrix Potter, 1902. Peter, a naughty young rabbit, defies his mother by sneaking into Mr. McGregor's garden, where he eats too many vegetables, winds up with a bad stomachache, and almost gets killed by Mr. McGregor.

The Talented Mr. Ripley, Patricia Highsmith, 1955. A psychological thriller set predominantly in Italy about Tom Ripley, an American who attempts to cover up his murder of an old acquaintance, Dickie Greenleaf, by masquerading alternately as his victim and himself.

To Kill a Mockingbird, Harper Lee, 1960. The story of Scout Finch, a young white girl living in the South during the Great Depression, whose lawyer father takes on a case defending a black man against a rape charge, causing the town to erupt in violent controversy.

To the Lighthouse, Virginia Woolf, 1927. The story of the Ramsay family and their visits to their summer home on the Isle of Skye, this novel uses stream-of-consciousness and changing perspectives as a means to examine time, emotional interiority, and human relationships.

Ulysses, James Joyce, 1922. This epic novel follows Leopold Bloom's journey on a single ordinary day as events bring him into contact with another truth-seeker, the younger Stephen Dedalus.

Valley of the Dolls, Jacqueline Susann, 1965. A chronicle of the lives of three young women—Anne, Jennifer, and Neely—and their great highs and lows as they avidly pursue fame, fortune, and love in the entertainment industry in New York City and Hollywood.

A Wrinkle in Time, Madeleine L'Engle, 1962. The adventures of teenager Meg Murry, who travels through space and time with her brother Charles Wallace and her friend Calvin O'Keefe in search of her missing scientist father.

BIBLIOGRAPHY

Books

Alcott, Louisa May. *Little Women*. Boston: Roberts Brothers, 1868–69. Reprinted with illustrations by Jessie Willcox Smith from the 1915 edition published by Little, Brown. New York: Children's Classics, 1988. Quotation from the 1988 edition.

Austen, Jane. *Emma*. London: John Murray, 1816. Reprint, New York: Penguin Books, 2003. Ed. Fiona Stafford. Quotation from the 2003 edition.

Ayto, John. *The Diner's Dictionary: Word Origins of Food and Drink*. 2nd ed. Oxford: Oxford University Press, 2012.

Birch, Dinah, ed. *The Oxford Companion to English Literature*. 7th ed. Oxford: Oxford University Press, 2009.

Boreth, Craig. *The Hemingway Cookbook*. Chicago: Chicago Review Press, 1998.

Bradbury, Ray. *Fahrenheit 451*. 1953. Paperback reprint edition, New York: Ballantine Books, 1991.

Burnett, Frances Hodgson. *The Secret Garden*. New York: Frederick A. Stokes, 1911. Reprinted with illustrations by Graham Rust, Boston: David R. Godine, 1994. Quotation from the 1994 edition.

Carroll, Lewis. *Alice's Adventures in Wonderland*. Illustrated by John Tenniel. London: Macmillan, 1865. Reprint, New York: Penguin Books, 1946. Quotation from the 1946 edition.

Chabon, Michael. *The Amazing Adventures of Kavalier and Clay*. New York: Random House, 2000.

Cortázar, Julio. *Hopscotch*. New York: Pantheon Books, 1966. Translated by Gregory Rabassa. Reprint, New York: Pantheon Books, 1987. Originally published as *Rayuela* [Buenos Aires: Sudamericana, 1963]. Quotation from the 1987 edition.

Defoe, Daniel. *Robinson Crusoe*. London: W. Taylor, 1719. Reprinted with illustrations by Richard Floethe as *The Life & Strange, Surprising Adventures of Robinson Crusoe of York, Mariner*. Mount Vernon, N.Y.: Peter Pauper Press, 1950. Quotation from the 1950 edition.

Dickens, Charles. *Oliver Twist*. London: Richard Bentley, 1838. Reprint, New York: Signet Classics, New American Library, 1961. Quotation from the 1961 edition.

Ditsky, John. *Essays on East of Eden*. Muncie, Ind.: John Steinbeck Society of America, English Dept., Ball State University, 1977.

du Maurier, Daphne. *Rebecca*. London: Victor Gollancz, 1938. Reprint, New York: William Morrow and Company, 1997. Quotation from the 1997 edition.

Ellis, Bret Easton. *American Psycho*. New York: Vintage Books, 1991.

Ephron, Nora. *Heartburn*. New York: Alfred A. Knopf, 1983.

Eugenides, Jeffrey. *Middlesex*. New York: Farrar, Straus and Giroux, 2002.

Fitzgerald, F. Scott. *The Great Gatsby*. New York: Charles Scribner's Sons, 1925. Reprint, New York: Scribner's, 1988. Quotation from the 1988 edition.

Flaubert, Gustave. *Madame Bovary*. New York: Oxford University Press, 2004. Translated by Margaret Mauldon and with an introduction by Malcolm Bowie. Originally published as *Madame Bovary; moeurs de Province* [Paris: Michel Lévy Frères, 1857]. Quotation from the 2004 edition.

Franzen, Jonathan. *The Corrections*. New York: Farrar, Straus and Giroux, 2001.

Hart, James D., and Phillip Leininger, eds. *The Oxford Companion to American Literature*. 6th ed. New York: Oxford University Press, 1995.

Hemingway, Ernest. *The Complete Short Stories of Ernest Hemingway*. New York: Scribner, 1987.

Herbst, Sharon Tyler, and Ron Herbst. *The Deluxe Food Lover's Companion*. Hauppauge, N.Y.: Barron's Educational, 2009.

Highsmith, Patricia. *The Talented Mr. Ripley*. New York: Coward-McCann, G. P. Putnam's Sons, 1955. Reprint, New York: W. W. Norton, 2008. Quotation from the 2008 edition.

Hoban, Russell. *Bread and Jam for Frances*. New York: Harper & Row, 1964.

Joyce, James. *Ulysses*. Paris: Shakespeare and Company, 1922. Paperback reprint edition, New York: Penguin Books, 1992. Quotation from the 1992 edition.

Kafka, Franz. *The Metamorphosis*. New York: Bantam Books, 1915. Reprint, New York: Penguin Books, 2006. Originally published as *Die Verwandlung* [Leipzig, Germany: Kurt Wolff, 1915]. Quotation from the 2006 edition.

Kerouac, Jack. *On the Road*. New York: Viking Press, 1957. Paperback reprint edition, New York: Penguin Books, 1999. Quotation from the 1999 edition.

Lahiri, Jhumpa. *The Namesake*. New York: Houghton Mifflin, 2003.

Larsson, Stieg. *The Girl with the Dragon Tattoo*. New York: Knopf, 2008.

Lee, Harper. *To Kill a Mockingbird*. Philadelphia: J.B. Lippincott, 1960. Reprint, New York: Grand Central Publishing, 1988. Quotation from the 1988 edition.

L'Engle, Madeleine. *A Wrinkle in Time*. Farrar, Straus and Giroux, 1962. Paperback reprint edition, New York: Dell Yearling Books, 1997. Quotation from the 1997 edition.

Lethem, Jonathan. *Motherless Brooklyn*. New York: Doubleday, 1999.

Lewis, C. S. *The Lion, the Witch and the Wardrobe*. London: Geoffrey Bles, 1950. Reprint, New York: Collier, 1970. Quotation from the 1970 edition.

Márquez, Gabriel García. *One Hundred Years of Solitude*. New York: Harper & Row, 1967. Reprint, New York: HarperCollins Publishers, 2003. Quotation from the 2003 edition.

McCarthy, Cormac. *The Road*. New York: Alfred A. Knopf, 2006.

McCloskey, Robert. *Blueberries for Sal*. New York: Viking Press, 1948.

Melville, Herman. *Moby-Dick; or The Whale*. New York: Harper & Brothers, 1851. Reprinted with illustrations by Rockwell Kent. New York: Modern Library, 1982. Quotation from the 1982 edition.

Mitchell, Margaret. *Gone with the Wind*. New York: Macmillan, 1936. Reprinted with a preface by Pat Conroy (75th Anniversary Edition). New York: Scribner, 2011. Quotation from the 2011 edition.

Montgomery, Lucy Maud. *Anne of Green Gables*. Boston: L.C. Page, 1908. Paperback reprint edition, New York: Bantam Books, 1982. Quotation from the 1982 edition.

Morrison, Toni. *The Bluest Eye*. New York: Holt, Rinehart and Winston, 1970. Reprinted with a foreword by Toni Morrison, Vintage International, New York, 2007. Quotation from 2007 edition.

Nabokov, Vladimir. *Lolita*. Paris: Olympia Press, 1955. Paperback reprint (50th Anniversary Edition), New York: Vintage, 1989. Quotation from the 1989 edition.

Plath, Sylvia. *The Bell Jar*. London: Heinemann, 1963. Reprinted with foreword by Frances McCullough. New York: Harper Perennial, HarperCollins, 1996. Quotation from the 1996 edition.

Potter, Beatrix. *The Tale of Peter Rabbit*. London: Frederick Warne, 1902.

Proust, Marcel. *Swann's Way*. Paris: Grasset, 1913. Reprinted with translation by Lydia Davis, New York: Viking Adult, 2003. Quotation from the 2003 edition.

Pynchon, Thomas. *Gravity's Rainbow*. New York: The Viking Press, 1973. Paperback reprint edition, New York, Penguin Books, 2000. Quotation from the 2000 edition.

Salinger, J. D. *The Catcher in the Rye*. New York: Little Brown, 1951. Reprint, New York: Little Brown, 1991. Quotation from the 1991 edition.

Schiff, Stacy. *Vera (Mrs. Vladimir Nabokov)*. New York: Random House, 1999.

Sendak, Maurice. *Nutshell Library*. New York: Harper & Row, 1962.

Spyri, Johanna. *Heidi*. Gotha, Germany: F. A. Perthes, 1880. Reprinted with introduction by Eva Ibbotson. New York: Puffin, 2009. Quotation from the 2009 edition.

Steinbeck, John. *East of Eden*. New York: The Viking Press, 1952. Paperback reprint edition, New York: Penguin Books, 1979. Quotation from the 1979 edition.

Steinbeck, John. *Journal of a Novel: The East of Eden Letters*. New York: Viking Press, 1969. Paperback reprint edition, 1972.

Susann, Jacqueline. *Valley of the Dolls*. New York: Bernard Geis Associates, 1965. Reprint, New York: Grove Press, 1997. Quotation from the 1997 edition.

Swift, Jonathan. *Gulliver's Travels*. London: Benjamin Motte, 1726. Reprinted with illustrations and decorations by W. A. Dwiggins. Mount Vernon, N.Y.: The Peter Pauper Press, 1950. Quotation from the 1950 edition.

Thompson, Hunter S. *Fear and Loathing in Las Vegas*. New York: Random House, 1971. Paperback reprint edition, New York: Vintage Books, 1998. Quotation from the 1998 edition.

Toole, John Kennedy. *A Confederacy of Dunces*. New York: The Grove Press, 1980.

Twain, Mark. *The Adventures of Huckleberry Finn*. New York: Charles Webster and Company, 1884 [1885]. Reprinted with an afterword by Alfred Kazin. Paperback edition, New York: Bantam Books, 1981. Quotation from the 1981 edition.

Woolf, Virginia. *To the Lighthouse*. London: Hogarth Press, 1927. Reprinted with a foreword by Eudora Welty, New York: Harcourt Brace, 1981. Quotation from the 1981 edition.

Articles

Cattaneo, Hank. "Backstage with Ol Blue Eyes." Sinatra.com. http://www.sinatra.com/legacy/backstage-with-ol-blue-eyes (accessed July 15, 2013).

"Chicken Soup Is Medicine, U.S. Scientists Confirm." CNN.com. October 17, 2000. http://archives.cnn.com/2000/HEALTH/diet .fitness/10/17/chicken.soup.reut/ (accessed July 15, 2013).

Cothran, Shannon. "12 Pickle Facts Everyone Should Immediately Commit to Memory." *Mental Floss*. July 27, 2009. mentalfloss .com/article/22347/12-pickle-facts-everyone-should-immediately -commit-memory (accessed July 15, 2013).

Fox, Margalit. "Leslie Buck, Designer of Iconic Coffee Cup, Dies at 87." *New York Times*, April 29, 2010.

Grimes, William. "A Man, a Plan, a Hot Dog: Birth of a Nathan's." *New York Times*, January 25, 1998.

Jenkins, Nancy Harmon. "From Italy, the Truth About Pasta." *New York Times*, September 17, 1997.

Kleiman, Dena. "Greek Diners, Where Anything Is Possible." *New York Times*, February 27, 1991.

Martineau, Chantal. "7 Things You Didn't Know About Ernest Hemingway's Drinking Habits." Food Republic. October 30, 2012. www.foodrepublic.com/2012/10/30/7-things-you-didnt-know -about-ernest-hemingways-dr (accessed July 15, 2013).

McGrath, Charles. "J. D. Salinger, Literary Recluse, Dies at 91." *New York Times*. January 28, 2010. www.nytimes.com/2010/01/29/books/29salinger.html (accessed July 15, 2013).

"Pie." *New York Times*, May 3, 1902.

Scribner III, Charles. "Celestial Eyes—from Metamorphosis to Masterpiece." www.sc.edu/fitzgerald/essays/eyes/eyes.html (accessed July 15, 2013).

"The Top 15 Most Popular Ice Cream Flavors." The Food Channel. July 20, 2008. www.foodchannel.com/articles/article/the-top-15-most-popular-ice-cream-flavors/ (accessed July 15, 2013).

"What's The Difference Between Sweet Potatoes and Yams?" *The Huffington Post*. www.huffingtonpost.com/2012/11/19/difference-between-sweet-potatoes-and-yams_n_1097840.html (accessed July 15, 2013).

Websites

agmrc.org (accessed July 15, 2013).

blueberrycouncil.org (accessed July 15, 2013).

foodreference.com (accessed July 15, 2013).

foodtimeline.org (accessed July 15, 2013).

jelly.org (accessed July 15, 2013).

kovels.com (accessed September 17, 2013).

wikipedia.org (accessed July 15, 2013).

Radio

"American Icons: The Great Gatsby." *Studio 360*. November 25, 2010.

"American Icons: Moby Dick." *Studio 360*. December 30, 2011.

ACKNOWLEDGMENTS

Many wonderful people have helped make this book possible. Special thanks to the writers, without whose words this book would not have been possible.

My thanks to everyone—family, friends, classmates, colleagues, and even strangers—who have not only supported *Fictitious Dishes* with great enthusiasm and voracious appetites but have also given me countless recommendations for new photos to take and new books to read. Thank you to Rob Giampietro, who encouraged me to begin this project in the first place. Many thanks to my research assistant, Rhiannon Marino, for indulging my love of minutiae, and to Juan Zambrano, for his amazing photo retouching work. Thank you to the dedicated and talented team at HarperCollins: Marta Schooler, Lynne Yeamans, Susan Kosko, Julie Hersh, Stephen Frankel, and particularly my superb editor and friend, Liz Sullivan, for her spirited collaboration and intense commitment to this book from the very beginning.

Thank you and love to my father, for teaching me to read carefully, and to my mother, for teaching me to look closely.

Finally, my gratitude and love to Joe, whose deep belief in this book, and me, is unwavering, and who inspires and encourages me to make better work every day.

ABOUT THE AUTHOR

Dinah Fried is a designer, writer, and amateur table-setter. She is a graduate of the Rhode Island School of Design, and her work has been widely recognized and featured in *The Guardian*, the *Huffington Post*, *New York* magazine, *The New Yorker*, *Bon Appétit*, National Public Radio, Andrew Sullivan's blog "The Dish," and *Print*. Her clients and collaborators include the Rhode Island School of Design, Chronicle Books, Etruscan Press, Persea Books, Oxford University Press, and the School of Visual Arts. She was featured in *Graphic Design USA* as a "person to watch" in 2012. She lives in San Francisco.